D0440997

art,
perception,
and reality

THE ALVIN AND FANNY BLAUSTEIN

THALHEIMER LECTURES

1970

MAURICE MANDELBAUM, EDITOR

art,
perception,
and reality

E. H. GOMBRICH

JULIAN HOCHBERG

MAX BLACK

THE JOHNS HOPKINS UNIVERSITY PRESS

BALTIMORE AND LONDON

Copyright © 1972 by The Johns Hopkins University Press. All rights reserved.
No part of this book may be reproduced or transmitted in any form or by any
means, electronic or mechanical, including photocopying, recording, xerography,
or any information storage and retrieval system, without permission in writing
from the publisher.
Manufactured in the United States of America

Originally published, 1972

Johns Hopkins Paperbacks edition, 1973
Second printing, 1977
Third printing, 1980
Fourth printing, 1984

The Johns Hopkins University Press, Baltimore, Maryland 21218
The Johns Hopkins Press Ltd., London

Library of Congress Catalog Card Number 76-186514

ISBN 0-8018-1354-9 (hardcover)
ISBN 0-8018-1552-5 (paperback)

contents

preface

The paths of art historians, psychologists, and philosophers do not normally converge, even when they are dealing with a common problem, since their aims and their methods are in most cases radically different. Yet, questions regarding the nature of representation in art have recently provided a common meeting ground, as the present volume of independent but related lectures indicates.

One work, above all others, stimulated this interest and has deeply influenced the course of these discussions: E. H. Gombrich's *Art and Illusion*. In a review of that book, Nelson Goodman called attention to its philosophic importance, and through his own *Languages of Art* Goodman has generated further interest in such questions among philosophers. It is hoped that by bringing together the contributions of an art historian, a psychologist, and a philosopher, this second series of Thalheimer Lectures will have made an important contribution to the ongoing discussion.

The point of departure for Professor Gombrich's essay, "The Mask and the Face," is an issue which he raised in his chapter on caricature in *Art and Illusion*. In the present essay he has extended

that problem to the whole question of physiognomic likeness. Crucial to this question is how there can be an underlying identity in the manifold and changing facial expressions of a single individual—changes which occur not only with changing emotions but with long-run changes over a span of time. With characteristic learning, insight, and deftness, Gombrich leads the reader through a variety of highly diverse examples and through a broad sample of the literature which has dealt with these and related topics. His interest in psychological theory is manifest throughout his discussion, but emerges most clearly in his defense of the theory of empathy as an explanation of many of the phenomena which are involved in the discernment of physiognomic resemblances.

In Julian Hochberg's contribution, the theory of empathy does not occupy a central position; what is taken as central are the expectancies aroused in the scanning processes occurring in visual perception. The theory he puts forward is an inclusive one, which he regards as capable of explaining the basic principles of visual organization without relying on either of two classical theories of perception: an empiricist theory, which he designates as Structuralism, and Gestalt psychology, which arose in opposition to that theory.

It is Professor Hochberg's contention that what is seen when we view a picture cannot be explained by appealing to the specific stimuli presented to the visual system, and he argues that such difficulties do not disappear even if one attempts to speak in terms of a field-theory of brain activity rather than in terms of specific stimuli. Instead, Hochberg argues that visual perception involves "skilled sequential purposive behavior," and he is interested in tracing how the sequential aspect of visual behavior is responsible for many of the most fundamental characteristics of the patterning of our visual world. Particularly relevant to problems of artistic representation is the doctrine which he advances concerning the canonical forms of objects, explaining the basis of such forms through his theory of what is encoded in our visual expectancies. It is at this point, and in his discussions of expressiveness and empathy, that Hochberg's essay makes direct contact with the views of Gombrich, in some ways substantiating those views but in others taking issue with them.

Max Black's essay seems at first glance remote from the two other contributions, since they concern perceptual processes and he addresses himself to a problem in conceptual analysis: what it means when we say of a picture that it depicts or represents something. The methods which he uses—the kinds of facts to which he appeals—are therefore entirely different; yet the issues involved in his analysis are directly connected with major issues involved in the other two articles. For example, while it is obvious that neither Gombrich nor Hochberg would accept "the causal history account" of what it means for a picture to depict a particular object, it was no part of the task of either to show that such a view is surely mistaken. Nevertheless, this is precisely the sort of account which many laymen are initially inclined to accept; once accepted, it leads to unfortunate consequences in aesthetic theory whenever problems concerning realistic representation, abstraction, and truth in art are discussed. These mistakes must be avoided for a proper reading of *Art and Illusion*, as well as for an appreciation of the present essays of Gombrich and Hochberg. It is therefore important to show, as Professor Black has incisively shown, that "the causal history account" is an inadequate account of what constitutes a representation. Similarly, his critical analysis of "depiction as illusion" is of immediate relevance to the views of Gombrich and Hochberg on pictorial representation.

This is not to say, of course, that the sole interest and importance of Professor Black's essay is confined to these issues; for example, his critical discussion of recent uses of the concept of "information" is an important contribution to the clarification of what has become almost a ubiquitous concept. Furthermore, his essay raises interesting issues concerning philosophical analysis, for it illustrates how various criteria may form a skein, being relevant to our use of a particular concept, even though they fail—when taken separately—to provide either necessary or sufficient characterizations of that concept.

The contributions of Professors Gombrich and Hochberg will also be of special interest to their professional colleagues: Professor Gombrich has focussed his attention on one central problem of outstanding importance, and Professor Hochberg has suggested a means of integrating a very wide range of experimental data within one theoretical framework. Each of these essays is, then, a distinc-

tive contribution in its own field, and will assuredly be welcomed by art historians and by psychologists.

The Department of Philosophy of The Johns Hopkins University, which sponsored these lectures, wishes once again to express its thanks to the Alvin and Fanny Blaustein Thalheimer Foundation for having made that sponsorship possible.

MAURICE MANDELBAUM

art,
perception,
and reality

E. H. GOMBRICH

the mask
and the face:
the perception of
physiognomic likeness
in life and in art

This essay[1] takes its starting point from a chapter in my book on *Art and Illusion*, the chapter entitled *The Experiment of Caricature*.[2] Caricature had been defined in the seventeenth century as a method of making portraits which aims at the greatest likeness of the whole of a physiognomy while all the component parts are changed. It could thus serve me for a demonstration of equivalence, the proof that the images of art can be convincing without being objectively realistic. I made no attempt, however, to investigate more precisely what was involved in the creation of a striking likeness. It does not look as if anyone has explored the whole vast area of portrait likeness in terms of perceptual psychology. There must be reasons for this omission even beyond the appalling complexity of

[1] An earlier version of this paper was read at a meeting on the psychology of art organized by Professor Max Black at Cornell University in September 1967.

[2] *Art and Illusion, A Study in the Psychology of Pictorial Representation*, The A. W. Mellon Lectures in the Fine Arts 1956, Bollingen Series XXXV, 5 (New York and London, 1960).

The standard books on portraiture are Wilhelm Waetzoldt, *Die Kunst des*

the problem. Somehow concern with likeness in portraiture bears the stamp of philistinism. It evokes the memory of quarrels between great artists and pompous sitters whose stupíd wife insists that there is still something wrong around the mouth. These dreaded discussions, which may be much less trivial than they sound, have made the whole question of likeness a rather touchy one. Traditional aesthetics have provided the artist with two lines of defence which have both remained in vogue since the Renaissance. One is summed up in the answer which Michelangelo is reported to have given when someone remarked that the Medici portraits in the *Sagrestia Nuova* were not good likenesses—what will it matter in a thousand years' time what these men looked like? He had created a work of art and that was what counted.[3] The other line goes back to Raphael[4] and beyond to a panegyric on Filippino Lippi who is there said to have painted a portrait that is more like the sitter than he is himself.[5] The background of this praise is the Neo-Platonic idea of the genius whose eyes can penetrate through the veil of mere appearances and reveal the truth.[6] It is an ideology which gives the artist the right to despise the sitter's philistine relatives who cling to the outward husk and miss the essence.

Whatever the use or abuse to which this line of defence has been put in the past and in the present, it must be granted that

Porträts (Leipzig, 1908), and Herbert Furst, *Portrait Painting, Its Nature and Function* (London, 1927). A brief bibliography of the subject can be found in Monroe Wheeler, *Twentieth Century Portraits* (The Museum of Modern Art, New York, 1942); to this might be added Julius von Schlosser, "Gespräch von der Bildniskunst" (1906), *Präludien* (Berlin, 1927); E. H. Gombrich, "Portrait Painting and Portrait Photography" in Paul Wengraf, ed., *Apropos Portrait Painting* (London, 1945); Clare Vincent, "In Search of Likeness," *Bulletin of the Metropolitan Museum of Art* (New York, April 1966); and John Pope-Hennessy, *The Portrait in the Renaissance*, The A. W. Mellon Lectures in the Fine Arts 1963, Bollingen Series XXXV, 12 (New York and London, 1966).

[3] Charles de Tolnay, *Michelangelo*, III (Princeton, 1948), p. 68.

[4] Vicenzio Golzio, *Raffaello nei documenti* (Vatican City, 1936), Letter by Bembo, 10th April 1516.

[5] Alfred Scharf, *Filippino Lippi* (Vienna, 1935), p. 92.

[6] Erwin Panofsky, *Idea*, Studien der Bibliothek Warburg (Hamburg, 1923; English translation, Columbia, 1968). For a recent statement of this point of view, see Ben Shahn, "Concerning 'likeness' in Portraiture," in Carl Nordenfalk, "Ben Shahn's Portrait of Dag Hammarskjöld," *Meddelanden från Nationalmuseum* No. 87 (Stockholm, n.d.).

here, as elsewhere, Platonic metaphysics can be translated into a psychological hypothesis. Perception always stands in need of universals. We could not perceive and recognise our fellow creatures if we could not pick out the essential and separate it from the accidental—in whatever language we may want to formulate this distinction. Today people prefer computer language, they speak of pattern recognition, picking up the invariants which are distinctive of an individual.[7] It is the kind of skill for which even the most hardened computer designers envy the human mind, and not the human mind only, for the capacity of recognising identity in change which it presupposes must be built into the central nervous system even of animals. Consider what is involved in this perceptual feat of visually recognising an individual member of a species out of the herd, the flock, or the crowd. Not only will the light and the angle of vision change as it does with all objects, the whole configuration of the face is in perpetual movement, a movement which somehow does not affect the experience of physiognomic identity or, as I propose to call it, physiognomic constancy.

Not everybody's face may be as mobile as that of Mr. Emanuel Shinwell whose characteristic changes of expression during a speech were caught by the candid camera of the London *Times*, but the example would seem to justify the reaction that we have not one face but a thousand different faces.[8] It might be objected that the unity in diversity here presents no logical or psychological problem, the face just shows different expressions as its mobile parts respond to the impulse of changing emotions. If the comparison were not so chilling, we might compare it to an instrument board with the mouth or the eyebrows each serving as indicators. This was indeed the theory of the first systematic student of human expression, Charles Le Brun, who based himself on Cartesian mechanics and saw in the eyebrows real pointers registering the character

[7] Thanks to the kindness of Mr. J. R. Pierce and of the author I was allowed to see a preprint of a paper based on research at the Bell Telephone Laboratories, by Leon D. Harmon, "Some Aspects of Recognition of Human Faces."

[8] This observation served Benedetto Croce as a convenient argument to deny the justification of any concept of "likeness" (*Problemi di Estetica*, (Bari, 1923), pp. 258–59). The English portrait painter Orpen took a similar line when his Portrait of the Archbishop of Canterbury was criticized: "I see seven Archbishops; which shall I paint?" (The anecdote was related by W. A. Payne, in a Letter to the London *Times*, March 5, 1970.)

3 THE MASK AND THE FACE

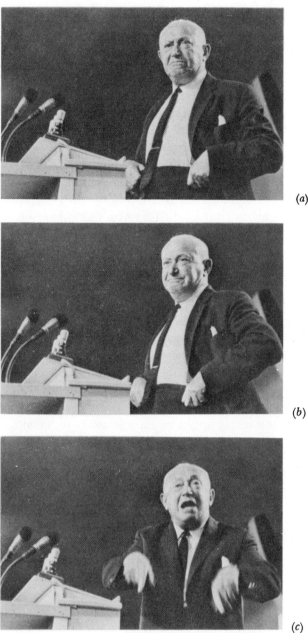

(a)

(b)

(c)

Fig. 1. *Emanuel Shinwell making a speech,*
from the London *Times,* 7 October 1966

FIG. 2. Charles Le Brun, *Astonishment*, 1698

of the emotion or passion.[9] On this reading of the situation, there is no more problem in our recognising Emanuel Shinwell in different moods than there is in recognising our watch at different hours. The framework remains and we quickly learn to separate the rigid bone structure of the head from the ripples of changes which play on its surface.

But clearly this explanation operates at best with a gross over-simplification. The framework does not remain static; we all change throughout our lives from day to day, from year to year. The famous series of Rembrandt's self-portraits from youth to old age shows the artist studying this relentless process, but it is only with the coming of photography that we have all become fully aware of this effect of time. We look at the snapshots of ourselves and of our friends taken a few years ago and we recognise with a shock that we all have changed much more than we tended to notice in the day-to-day business of living. The better we know a person, the more

[9] Jennifer Montagu, "Charles Le Brun's *Conférence sur l'expression*," unpublished Ph.D. thesis, University of London, 1960. The full Cartesian implications of Le Brun's exposition were only brought out in this analysis.

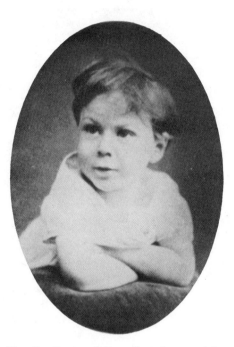

Fig. 3. *Bertrand Russell at the age of four*

often we see the face, the less do we notice this transformation except, perhaps, after an illness or another crisis. The feeling of constancy completely predominates over the changing appearance. And yet, if the time-span is long enough this change also affects the frame of reference, the face itself, which a vulgarism actually calls the "dial." It does so most thoroughly throughout childhood when proportions change and we first acquire a proper nose, but it also does so once more in old age when we lose our teeth and our hair. Yet all growth and decay cannot destroy the unity of the individual's looks—witness two photographs of Bertrand Russell, as a child of four and at the age of ninety. It certainly would not be easy to programme a computer to pick out the invariant, and yet it is the same face.

If we watch ourselves testing this assertion and comparing the two pictures, we may find that we are probing the face of the child trying to project into it, or onto it, the more familiar face of the aged philosopher. We want to know if we can see the likeness or,

FIG. 4. *Bertrand Russell at the age of ninety,*
photographed by Lotte Meitner-Graf

if our mental set is one of scepticism, we want to prove to ourselves that we cannot see it. In any case those who are familiar with Bertrand Russell's striking features will inevitably read the comparison from right to left, and try to find the old man in the young child; his mother, if she could be alive, would look in the features of the old man for the traces of the child, and having lived through this slow transformation, would be more likely to succeed. The experience of likeness is a kind of perceptual fusion based on recognition, and here as always past experience will colour the way we see a face.

It is on this fusion of unlike configurations that the experience of physiognomic recognition rests. Logically, of course, anything can be said to be like any other thing in some respect, and any child can be argued to be more like any other child than like an old man, indeed any photograph can be argued to be more like any other photograph than any living person. But such quibbles are only helpful if they make us aware of the distance that separates

logical discourse from perceptual experience. Rationally we are free to categorise things in any number of ways and order them according to any quality they may have in common, be it weight, colour, size, function, or shape. Moreover, in this ordering activity we can always specify in which respect one thing is like another.

That physiognomic likeness which results in fusion and recognition is notoriously less easy to specify and analyse. It is based on what is called a global impression, the resultant of many factors which yet in their interaction make for a very particular physiognomic quality. Many of us would be unable to describe the individual features of our closest friends, the colour of their eyes, the exact shape of their noses, but this uncertainty does not impair our feeling of familiarity with their features which we would pick out among a thousand because we respond to their characteristic expression. Clearly we must not confuse this experience with the perception of contrasting expressions on a person's face. Just as we can generalise on a person's voice or on the duct of his handwriting through all the varieties of tone or line, so we feel that there is some general dominant expression of which the individual expressions are merely modifications. In Aristotelian terms it is his substance of which all modifications are mere accidents, but it can transcend the individual in the experience of family likeness so marvellously described in a letter by Petrarch. Petrarch discusses the problem of imitating the style of an admired author and says that the similarity should be like that between a son and his father, where there is often a great difference between their individual features "and yet a certain shadow, or what our painters call the *aria*, reminds us of the father as soon as we see the son, even though, if the matter were put to measurement, all parts would be found to be different."[10]

We all know such examples of family likeness, but all of us have also been irritated by the talk of visiting aunts about baby looking "exactly like" uncle Tom or uncle John, assertions which are sometimes countered with the remark "I cannot see this." For the student of perception such discussions can never be boring, the very disagreement about what they see is grist for the mill of those

[10] Francesco Petrarca, *Le famigliari XXIII*, 19, 78–94. For the full text see also my paper on "The Style *all' antica*," *Norm and Form* (London, 1966).

of us who look at perception as a nearly automatic act of categorising in universals. What people experience as likeness throws light on their perceptual categories. Clearly we do not all have the same impression of a person's *aria* or characteristic face. We do see them differently according to the categories with which we scan our fellow creatures. This fact, perhaps, accounts for the central paradox in the field of physiognomic perception, the one which is implied in the distinction between the mask and the face: the experience of the underlying constancies in a person's face which is so strong as to survive all the transformations of mood and age and even to leap across generations, conflicts with the strange fact that such recognition can be inhibited with comparative ease by what may be called the mask. This is the alternative category of recognition, the

FIG. 5 (*left*). *Ruth Draper as the businessman's wife,* photographed by Dorothy Wilding

FIG. 6 (*right*). *Ruth Draper as the businessman's secretary,* photographed by Nicholas Murray

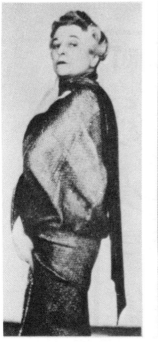 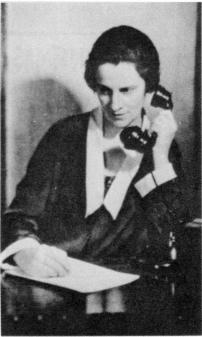

cruder type of likeness which can throw the whole mechanism of physiognomic recognition into confusion. The art which experiments with the mask is of course the art of disguise, of acting. The whole point of the actor's skill is precisely this: to compel us to see him or her as different people according to the different roles. The great actor does not even need the mask of make-up to enforce this transformation. A great impersonator such as Ruth Draper was able to transform herself from scene to scene with the simplest of means. The illustrations show her as two women in the life of one businessman, the haughty wife and the devoted secretary. The scarf, the costume, and the wig may help, but what really effected the transformation was the difference in posture, in the whole tonus of the persons represented.

Sociologists have increasingly reminded us of the truth that we are all actors, we all obediently play one of the roles which our society offers to us—even the "hippies" do. In the society with which we are familiar we are extremely sensitive to the outward signs of these roles and much of our categorisation proceeds along

FIG. 7. David Low, *Colonel Blimp*, 1936

these lines. We have learned to distinguish the types with which our writers and satirists keep us in touch: there is the military type, David Low's Colonel Blimp of blessed memory, the sporty type, the arty type, the executive, the academic type, and so all through the repertory of the comedy of life. Clearly this knowledge of the cast permits a great economy of effort in dealing with our fellow creatures. We see the type and adjust our expectations: the military red-faced man will have a booming voice, like strong drink, and dislike modern art. True, life has also taught us that we must be prepared for such syndromes to be incomplete. In fact whenever we meet the exception to this rule and find the perfect embodiment of a type we are apt to say, "this man is so much the typical Central European intellectual it just is not true." But it often is true. We model ourselves so much on the expectation of others that we assume the mask or, as the Jungians say, the *persona* which life assigns to us, and we grow into our type till it moulds all our behaviour, down to our gait and our facial expression. It seems there is nothing to exceed the plasticity of man except, of course, the plasticity of woman. Women work more consciously on their type and image than most men used to do, and often they try by means of make-up and hair style to shape themselves in the image of some fashionable idol of the screen or of the stage.[11]

But how do these idols shape their image? The language of fashion gives at least a partial answer. They look for a distinctive note, for a striking characteristic that will mark them out and attract attention through a new kind of piquancy. One of the most intelligent of stage personalities, the late Yvette Guilbert, described in her memoirs how she deliberately set about in her youth to create her type by deciding that, since she was not beautiful in the conventional sense, she would be different. "My mouth," she writes, "was narrow and wide and I refused to reduce it through make-up, because at that time all the women of the stage had tiny heart-shaped mouths."[12] Instead, she emphasised her lips to contrast with her pale face and to bring out her smile. Her dress was to be simple as a shift, she wore no ornament, but she completed her striking silhouette by adopting the long black gloves which became famous.

[11] Liselotte Strelow, *Das manipulierte Menschenbildnis* (Düsseldorf, 1961).

[12] Yvette Guilbert, *La chanson de ma vie* (Paris, 1927).

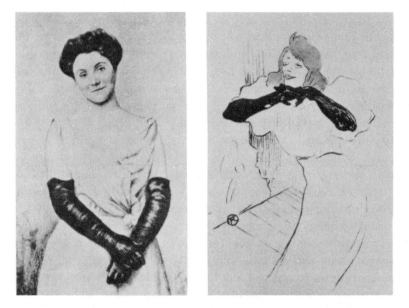

FIG. 8 *(left)*. *Yvette Guilbert*, by Rennewitz von Loefen, 1899
FIG. 9 *(right)*. *Yvette Guilbert*, lithograph by Toulouse Lautrec

Thus her image which was a deliberate creation met the artist half way, because it could be summed up in those few telling strokes we remember from the lithographs of Toulouse Lautrec.

We are approaching the area of caricature, or rather that borderland between caricature and portraiture which is occupied by images of stylised personalities, all the actors on the public stage who wear their mask for a purpose. Think of Napoleon's forelock and of that gesture of standing with the hand tucked into his waist-coat which the actor Talma is said to have suggested to him. It has remained a godsend to impersonators and cartoonists seeking a formula for a Napoleonic aspiration—and so have the other tricks adopted by the lesser Napoleons we have had to endure.

It hardly matters how trivial the distinctive trait may be which is taken up, provided it remains consistently identifiable. Hitler's financial wizard, Hjalmar Schacht, was apparently in the habit of wearing a relatively high starched collar. The collar itself somehow evokes the social type of the rigid Prussian moving in the company of upright executives. It would be interesting to find out by how

much the height of Schacht's collar exceeded the average of his class; at any rate, the deviation stuck and gradually the collar could replace the likeness of the man. The mask swallowed up the face.

If these examples have suggested anything, it is that we generally do take in the mask before we notice the face. The mask here stands for the crude distinctions, the deviations from the norm which mark a person off from others. Any such deviation which attracts our attention may serve us as a tab of recognition and promises to save us the effort of further scrutiny. For it is not really the perception of likeness for which we are originally programmed, but the noticing of unlikeness, the departure from the norm which stands out and sticks in the mind. This mechanism serves us in good stead as long as we move in familiar surroundings and have to mark the slight but all-important differences which distinguish one individual from another. But once an unexpected

FIG. 10 (*left*). "Kobbe," *Hjalmar Schacht,* M.M., *Der Montag Morgen,* 10 March 1924
FIG. 11 (*right*). Caricature of Schacht, *8 Uhr Abendblatt,* Berlin, 13 June 1932. Caption reads: "Look out! A high collar has turned up again!"

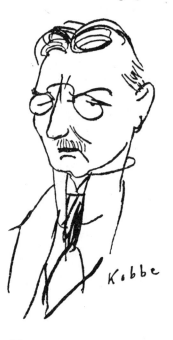

Kobbe

Achtung!
Ein Stehkragen taucht wieder auf!

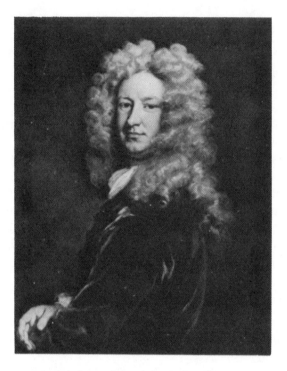

FIG. 12. *Sir Samuel Garth*, by G. Kneller,
National Portrait Gallery, London

distinctive feature obtrudes itself the mechanism can jam. It is said that all Chinese look alike to Westerners and all Westerners to Chinese. This may not be strictly true, but the belief reveals an important feature of our perception. One might indeed compare the effect with what is known as the masking effect in the psychology of perception where a strong impression impedes the perception of lower thresholds. A bright light masks the modulations of the dim nuances in the vicinity just as loud tone masks subsequent soft modulations of sound. Such unaccustomed features as slanting eyes will at first rivet our attention and make it hard for us to attend to the subtle variations. Hence the effectiveness also of any striking and unusual mark as a disguise. It is not only all Chinese who tend to look alike to us but also all men in identical wigs such as the members of the eighteenth-century Kitkat Club displayed in the National Portrait Gallery in London.

How far do such portraits represent types or masks, and how

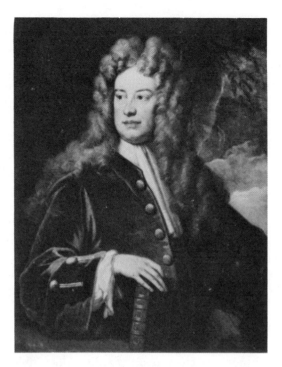

far are they individual likenesses? Clearly there are two difficulties
in answering this important question, one obvious, the other per-
haps less so. The obvious difficulty is the same with all portraits of
people before the invention of photography—we have very few
objective controls about the sitter's appearance except occasionally
a life—or a death—mask or a tracing of the shadow as a silhouette.
We shall never know whether we would recognise Mona Lisa or the
Laughing Cavalier if we met them in the flesh. The second difficulty
springs from the fact that we ourselves are trapped by the mask and
therefore find it hard to perceive the face. We have to make an
effort to abstract from the wig to see how far these faces differ, and
even then changing ideas of decorum and deportment, the social
mask of expression, make it hard for us to see the person as an
individual. Art historians often write of certain periods and styles
that portraits at that time were confined to types rather than to
individual likeness, but much depends on how one decides to use

15 THE MASK AND THE FACE

these terms. Even the stereotypical images of tribal art have been known to embody an individual distinctive feature which would escape us since we neither know the person represented nor the stylistic conventions of the tribe. One thing is sure, moreover: it is almost impossible for us to see an old portrait as it was meant to be seen before the snapshot and screen spread and trivialised the likeness, for we can hardly recapture the full significance of an image commissioned and made to sum up the sitter's social status and career, and to hand down his features as a memorial to his descendants and as a monument to later ages. Obviously in such a situation the portrait had quite a different weight. The artist's reading of the sitter's features would impose itself during his life-time and would totally take over after his death in a manner we can neither hope for, nor need fear, since the multiplicity of records we have will always counter such a psychological take-over bid.

No wonder the coming of the camera found the artists and their friends in a bewildered and aggressive mood. Some of the arguments used against the possibility of a photographic likeness produced in the nineteenth century look surprising to us, for many now will prefer Nadar's splendid portrait of Franz Liszt which shows the great virtuoso, warts and all, to the rather theatrical painting by Franz Lenbach, but, again, we must admit that we have never known Liszt. Here the question is really whether we can even see photographs in the same way in which they were first seen. The candid camera and the television screen have completely changed our mental set towards the image of our contemporaries. Such intimate snapshots as those showing our modern Franz Liszt, Sviatoslav Richter, at rehearsals in shirtsleeves would not only have been technically impossible in the nineteenth century, they would also have been psychologically unacceptable, they would have struck our grandfathers as both indecorous and totally unrecognisable.

But though the snapshot has transformed the portrait it has also made us see that problem of likeness more clearly than past centuries were able to formulate it. It has drawn attention to the paradox of capturing life in a still, of freezing the play of features in an arrested moment of which we may never be aware in the flux of events. Thanks to the work of J. J. Gibson in the psychology of perception we have become increasingly aware of the decisive role

which the continuous flow of information plays in all our commerce with the visible world.[13] Hence we also understand a little more wherein rests what might be called the artificiality of art, the confinement of the information to simultaneous cues. To put the matter crudely—if the film camera rather than the chisel, the brush, or even the photographic plate had been the first recorder of human physiognomies, the problem which language in its wisdom calls "catching a likeness" would never have obtruded itself to the same extent on our awareness. The film shot can never fail as signally as the snapshot can, for even if it catches a person blinking or sneezing the sequence explains the resulting grimace which the corresponding snapshot may leave uninterpretable. Looked at in this way, the miracle is not that some snapshots catch an uncharacteristic aspect, but that both the camera and the brush can abstract from movement and still produce a convincing likeness not only of the mask but also of the face, the living expression.

Clearly the artist or even the photographer could never overcome the torpor of the arrested effigy if it were not for that characteristic of perception which I described as "the beholder's share" in *Art and Illusion*. We tend to project life and expression onto the arrested image and supplement from our own experience what is not actually present. Thus the portraitist who wants to compensate for the absence of movement must first of all mobilise our projection. He must so exploit the ambiguities of the arrested face that the multiplicities of possible readings result in the semblance of life. The immobile face must appear as a nodal point of several possible expressive movements. As a professional photographer once told me with a pardonable overstatement, she searches for the expression which implies all others. A scrutiny of successful portrait photographs confirms indeed this importance of ambiguity. We do not want to see the sitter in the situation in which he actually was—having his portrait taken. We want to be able to abstract from this memory and to see him reacting to more typical real-life contexts.

The story of one of the most successful and most popular photographs of Winston Churchill as a war leader may illustrate this point. We are told by Yosuf Karsh how unwilling he found the

[13] J. J. Gibson, *The Senses Considered as Perceptual Systems* (Boston, 1966).

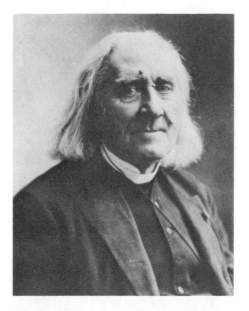

FIG. 14. *Franz Liszt*, photographed by Nadar

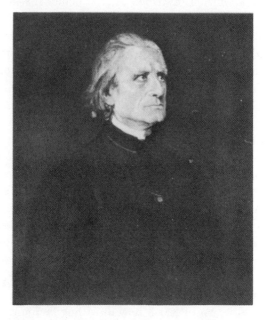

FIG. 15. *Franz Liszt*, painting by Franz Lenbach,
Budapest, Museum of Fine Art

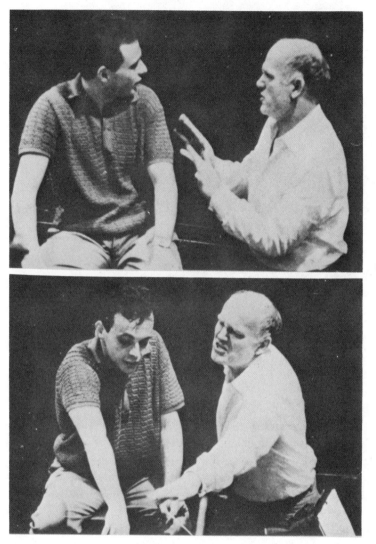

(a)

(b)

Fig. 16. *Sviatoslav Richter,* photographed during rehearsal,
Photo Ellinger, Salzburg

19 THE MASK AND THE FACE

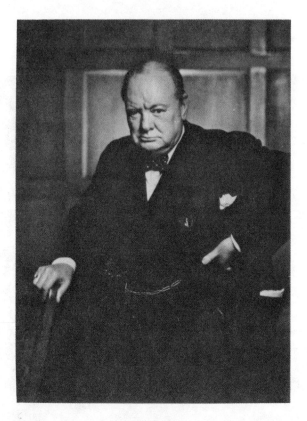

FIG. 17. *Winston Churchill,* photographed by Karsh, Ottawa

busy Prime Minister to pose for this photograph during a visit to Ottawa in December 1941. All he would allow was two minutes as he passed from the chamber of the House to the anteroom. As he approached with a scowl, Karsh snatched the cigar from his mouth and made him really angry. But that expression which was in reality no more than a passing reaction to a trivial incident was perfectly suited to symbolise the leader's defiance of the enemy. It could be generalised into a monument of Churchill's historic role.[14]

Admittedly it is not very usual for photographers to exploit the ambiguity or interpretability of an angry frown. More often they ask us to smile, though folklore has it that if we say 'cheese' this produces the same effect around the mouth. The arrested smile is

[14] Yosuf Karsh, *Portraits of Greatness* (Edinburgh, 1959).

certainly an ambiguous and multi-valent sign of animation which has been used by art to increase the semblance of life ever since archaic Greece. The most famous example of its use is of course Leonardo's *Mona Lisa*, whose smile has been the subject of so many and so fanciful interpretations. Maybe we can still learn more about this effect by comparing common-sense theory with unexpected but successful practice.

Roger de Piles (1635–1709) to whom we owe the first detailed discussion of the theory of portrait painting advises the painter to attend to expression:

> It is not exactness of design in portraits that gives spirit and true air, so much as the agreement of the parts at the very moment when the disposition and temperament of the sitter are to be hit off....
>
> Few painters have been careful enough to put the parts well together: Sometimes the mouth is smiling, and the eyes are sad; at other times, the eyes are chearful, and the cheeks lank; by which means their work has a false air, and looks unnatural. We ought therefore to mind, that, when the sitter puts on a smiling air, the eyes close, the corners of the mouth draw up towards the nostrils, the cheeks swell, and the eyebrows widen.[15]

Now if we compare this sound advice with a typical eighteenth century portrait such as Quentin de la Tour's charming pastel of his mistress Mlle Fel, we see that her eyes are by no means closed as in a smile. And yet the very combination of slightly contradictory features, of a serious gaze with a shadow of a smile results in a subtle instability, an expression hovering between the pensive and the mocking that both intrigues and fascinates. True, the game is not without its risk, and this perhaps explains the degree to which the effect froze into a formula in the eighteenth century portraits of polite society.

The best safeguard against the "unnatural look" or the frozen mask has always been found in the suppression rather than the employment of any contradictions which might impede our projection. This is the trick to which Reynolds referred in his famous analysis of Gainsborough's deliberately sketchy portrait style which I quoted and discussed in *Art and Illusion*. Photographers such as Steichen

[15] Roger de Piles, *Cours de Peinture par Principes* (Paris, 1708), p. 265. I quote from the English translation (London, 1743), pp. 161–62.

FIG. 18. *Mademoiselle Fel*, pastel by Maurice Quentin de la Tour, Musée a Lécuyer, St. Quentin

have aimed at a similar advantage by a combination of lighting and printing tricks, to blur the outline of a face and thus to mobilise our projection, and graphic artists, such as Felix Valloton in his portrait of *Mallarmé*, have also aimed at similar effects of simplification, much discussed at the turn of the century.[16]

We enjoy this game and we rightly admire the painter or the caricaturist who can, as the saying goes, conjure up a likeness with a few bold strokes, by reducing it to essentials. But the portrait painter also knows that the real trouble starts when you have to proceed in the opposite direction. However skilful he may have been with the first rough outline, he must not spoil the sketch on the way to the finished portrait, because the more elements he has to handle, the harder it is to preserve the likeness. From this point of view the experience of the academic portrait painter is almost more interesting than that of the caricaturist. A remarkably circumspect and revealing report on the problem of catching a likeness can

[16] See the dialogue on portraiture by J. von Schlosser, quoted above, note 2.

Fig. 19. Felix Valloton, *Mallarmé*

be found in a book on the practical problems of the portrait painter by Janet Robertson whose paintings belong to the tradition of formal portraiture:

... there are certain errors one learns to look for as the possible cause of untrue expression. Does there seem too "sharp" a quality? Check carefully that the eyes are not too close together; is the look, on the other hand, too "vague"? Make sure they are not too far apart—often, of course, the drawing can be correct, but overemphasis or underemphasis of shadows may seem to draw the eyes together or widen the distance between them. If, in spite of a conviction that you have drawn the mouth correctly, it still somehow looks wrong, check the surrounding tones, especially that on the upper lip (i.e., the whole region between nose and mouth); an error in the tone of this passage can make all the difference in bringing the mouth forward or sending it back, a matter that affects expression at once. If you feel there is something wrong and you cannot locate it, check the position of the ear.... Now, if the ear is placed wrongly it alters the whole impression of the facial angle and you may remedy a jowly look or a weak look by correcting that error without touching those features with the expression of which you have been struggling in vain.[17]

[17] Janet Robertson, *Practical Problems of the Portrait Painter* (London, 1962).

23 THE MASK AND THE FACE

FIG. 20. Toepffer, *The Permanent Traits*,
from the *Essay du Physiognomonie*, 1845

This description by a painter who had the humility of listening
to lay criticism is so instructive because it spells out certain relation-
ships between the shape of the face and what the author calls its
expression. What she means has less to do with the play of expres-
sions than with what Petrarch called the *air* of the face. We re-
member that this expression is not the same as its expressions. The
distance of the eyes or the angle of the face are, after all, a matter
of bone structure which is unalterable, and yet, as the painter
found, it radically influences that over-all quality one might per-
haps call the dominant expression. The facts are not in doubt.
Long before psychological laboratories were even thought of, artists
made systematic experiments which established this dependence. I
have paid tribute in *Art and Illusion* to the most thorough and
sophisticated of these experimenters, Rodolphe Toepffer, who estab-
lished what I have proposed to call Toepffer's law, the proposition
that any configuration which we can interpret as a face, however
badly drawn, will *ipso facto* have such an expression and individual-
ity.[18] Almost a hundred years after Toepffer, the psychologist Egon

[18] R. Toepffer, *Essai de physiognomonie* (Geneva, 1845). English translation by
E. Wiese, under the title *Enter the Comics* (Lincoln, Nebraska, 1965).

	T7	W7	D7	W4	G7
Sad	1st				
Old	1st				
Bad	6th	5th			
Unlikeable	3rd	1st	7th		
Ugly	6th	2nd	1st		
Unintelligent		3rd	7th	1st	
Unenergetic					1st

FIG. 21. *Schematic heads*, after Brunswik and Reiter

Brunswik in Vienna launched a famous series of experiments to probe this kind of dependence. His studies confirm the extreme sensitivity of our physiognomic perception to small changes; a shift in the distance of the eye which would perhaps be unnoticeable in a neutral configuration may radically affect the expression of the mannikin, though how it will affect it is not always easy to predict.

· Brunswik moreover in a subsequent discussion of his own and other people's findings was careful to warn against generalising his results:

Human appearance and especially the face, constitutes as tight a package of innumerable contributing variables as might be found anywhere in cognitive research.

He goes on reminding us that any new variable introduced may nullify the effect observed in the interaction of others. But—and this was the burden of his difficult methodological book—"the situation is the same for all high-complexity problems of life and behaviour."[19]

[19] Egon Brunswik, *Perception and the Representative Design of Psychological Experiments*, 2nd ed. (Berkeley, 1956), p. 115.

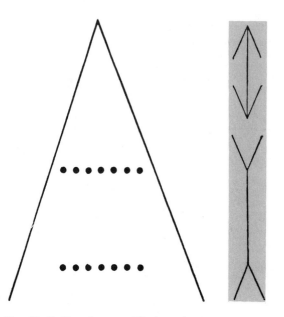

FIG. 22 *(left)*. *Contrast illusion*, after M. D. Vernon

FIG. 23 *(right)*. *Müller-Lyer illusion*, after M. D. Vernon

In a sense, one might say, Brunswik encourages the innocent humanist to rush in where angels armed with the tools of factor analysis fear to tread. The mutual interaction of variables in the face has been handled as we have seen, by portrait and mask makers alike. Brunswik refers his scientific readers to the book by a make-up expert. Indeed I would not be surprised if experience in these fields could throw light on unexpected places. Take the problem of headgear and the way it affects the apparent shape of the face. In widening the area around the face two conflicting psychological mechanisms might come into play. The effect of contrast exemplified in a well-known illusion might make the face look narrower. Alternatively we remember the Müller-Lyer illusion which suggests that the addition on either side must rather appear to broaden the face. Now if it is true that the slightest shift in the distance of the eyes results in a noticeable difference of expression and if Janet Robertson is right that eyes further apart give the face a vague expression, this observation might enable us to decide between these mutually exclusive alternatives. Let us try and screen

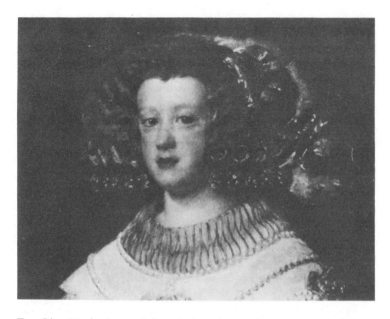

Fig. 24. *Maria Anna of Austria,* by Diego Velazquez, Paris, Louvre

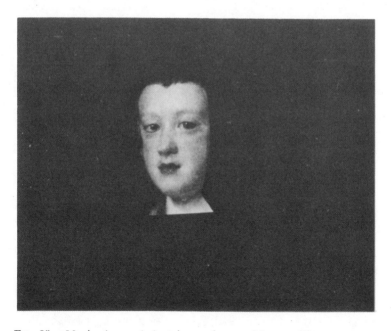

Fig. 25. *Maria Anna of Austria,* as above, without coiffure

27 THE MASK AND THE FACE

off the monstrous coiffure of one of Velazquez's portraits of a Spanish princess, whose appearance usually strikes one as sadly pudding-faced. Does not her gaze acquire more life, intensity and even intelligence when we remove the sideway extensions? The eyes, apparently, move together, which suggests that the effect conforms to the Müller-Lyer illusion.

It is in this area of the interaction between the apparent shape and the apparent expression that we must look for the solution of our problem, the problem of the artist's compensation for the absence of movement, his creation of an image which may be objectively unlike in shape and colour and is yet felt to be like in expression.

There is a telling account given by Mme Gilot of Picasso painting her portrait which supports this assertion to a striking degree. The artist, we hear, originally wanted to do a fairly realistic portrait, but after working a while he said: "No, it is just not your style, a realistic portrait would not represent you at all." She had been sitting down but now he said: "I do not see you seated, you are not at all the passive type, I only see you standing."

Suddenly he remembered that Matisse had spoken of doing my portrait with green hair and he fell in with the suggestion. "Matisse isn't the only one who can paint you with green hair," he said. From that point the hair developed into a leaf form, and once he had done that, the portrait resolved itself in a symbolic floral pattern. He worked in the breasts with the same curving rhythm. The face had remained quite realistic all during these phases. It seemed out of character with the rest. He studied it for a moment. "I have to bring in that face on the basis of another idea," he said. "Even though you have a fairly long oval face, what I need in order to show its light and its expression is to make it a wide oval. I'll compensate for the length by making it a cold colour— blue. It will be like a little blue moon."

He painted a sheet of paper sky-blue and began to cut out oval shapes corresponding in varying degrees to this concept of my head: first, two that were perfectly round; then, three or four more based on his idea of doing it in width. When he had finished cutting them out, he drew in on each of them little signs for the eyes, nose, and mouth. Then he pinned them onto the canvas, one after another, moving each one a little to the left or right, up or down, as it suited him. None seemed really appropriate until he reached the last one. Having tried all the others in various spots, he knew where he wanted it, and when he applied it to the canvas, the form seemed exactly right in just the spot he put it on. It was

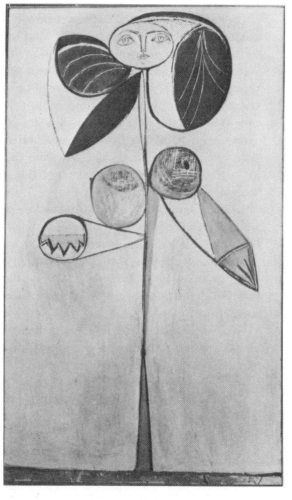

Fig. 26 (*left*). *Françoise Gilot,* Photo Optica

Fig. 27 (*right*). *Françoise Gilot, "Femme Fleur"* by Picasso

completely convincing. He stuck it to the damp canvas, stood aside, and said, "Now, it's your portrait."[20]

This record gives us some hints about the lines along which the transposition from life into image may occur. It is a balancing of compensatory moves. To compensate for her face not being really oblong but narrow, Picasso paints it blue—maybe the pallor is here felt to be an equivalent to the impression of slimness. Not that even Picasso felt able to find the exact balance of compensations without trying them out: he tested a number of cardboard shapes. What he was searching for is precisely the equivalent, equivalent at least for him. This, as the saying goes, is how he saw her, or as we should rather say, how he felt her. He groped for the solution of an equation between life and image, and like the conventional portrait artist he tried to catch it by playing with the interaction between shape and expression.

The complexity of this interaction explains not only why women try on new hats in front of a mirror but also why likeness has to be caught rather than constructed; why it needs the method of trial and error, of match-mismatch to trap this elusive prey. Here as in other realms of art equivalence must be tested and criticised, it cannot be easily analyzed step by step and therefore predicted.

We are far removed from what might be called a transformational grammar of forms, a set of rules which allows us to refer the different equivalent structures back to one common deep structure as has been proposed in the analysis of language.[21]

But though such a transformational grammar will always prove a will-of-the-wisp, maybe the problem of portrait equivalence allows us still to go one or two small steps forward. If the problem of likeness is that of the equivalence of the dominant expression, this expression or air must remain the pivot around which all the transformations turn. The different sets of variables must combine to the

[20] Françoise Gilot and Carlton Lake, *Life with Picasso* (New York, 1964).

[21] In a note to my paper on "The Variability of Vision" (C. S. Singleton, ed., *Interpretation, Theory and Practice* (Baltimore, 1969), pp. 62–63) I ventured to compare some interpretative processes in perception with linguistic phenomena investigated by N. Chomsky. I was all the more interested to see that Professor Chomsky was reported in *The New Yorker* of May 8, 1971, p. 65, to compare our disposition to understand facial expression with our linguistic equipment.

same result, it is an equation in which we are confronted with the product of y and x. (Increase y and you must decrease x, or vice versa, if you want the same result.)

There are many areas in perception where this situation obtains. Take size and distance which together produce the retinal size of the image; if other cues are eliminated we cannot tell whether an object seen through a peephole is large and far or near and small, we have no values for x and y, only for the product. Similarly with colour perception, where the resultant sensation is determined by the so-called local colour and the illumination. It is impossible to tell whether the patch of colour seen through a reduction screen is a dark red seen in bright light or a bright red in dim light. Moreover, if we call y the colour and x the light we never have any of these variables neat as it were. We cannot see colour except in light, and therefore that "local colour" which figures in books on painting as "variously modified by light," is a construction of the mind. Yet, though it is logically a construction, we feel quite confident in our experience that we do and can separate the two factors and assign their relative shares to colour and illumination. It is on this separation that the so-called colour constancy is pivoted, just as size constancy is pivoted on our interpretation of the object's real size.

I think that a somewhat analogous situation exists in the perception of physiognomic constancies, even though, as Brunswik told us, the number of variables there is infinitely larger. Granted that they are, I propose as a first approximation to isolate the two sets which I have mentioned before, the mobile and the static ones. Remember the crude analysis of the face as a dial or instrument board in which the mobile features serve as pointers to changing emotions. Toepffer called these features the impermanent traits which he contrasted with the permanent traits, the form or structure of the board itself. In one sense, of course, this analysis is quite unreal. What we experience is the global impression of a face, but in responding to this resultant I would suggest we separate in our mind the permanent (p) from the mobile (m). In real life we are aided in this, as we are aided in the perception of space and of colour by the effect of movement in time. We see the relatively permanent forms of the face standing out against the relatively mobile ones and thus form a provisional estimate of their interaction (pm).

It is this dimension of time, above all, we lack in the interpretation of a still. Like many pictorial problems, the problem of portrait likeness and expression is compounded here, as we have seen, by the artificial situation of arrested movement. Movement always assists in confirming or refuting our provisional interpretations or anticipations, and hence our reading of the static images of art is particularly prone to large variations and contradictory interpretations.

When somebody is disappointed we say "he pulls a long face," an expression vividly illustrated in a German caricature of 1848. Naturally there are people who have a long face, and if they are comedians, they can even exploit this disappointed look to good effect. But if we really want to interpret their expression we must

FIG. 28. Kaspar Braun, *The News of 1848*, in *Fliegende Blätter*

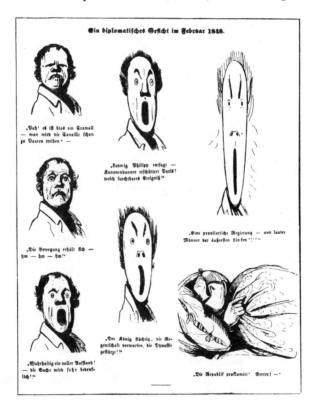

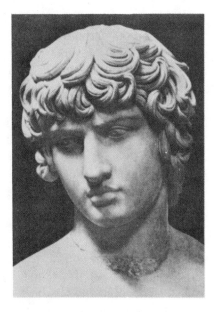

FIG. 29. *Antinous,* Roman sculpture, Naples Museum

assign any feature to one of the two sets of variables p or m, the permanent (p) or the mobile (m), and this separation may sometimes go wrong.

The difficulty in solving this equation may in fact account for the astonishing diversity of interpretations we sometimes encounter in relation to works of art. A whole book was written in the nineteenth century collecting the varying readings of the facial expression of the Roman portraits of Antinous.[22] One of the reasons for this divergence may be the difficulty in assigning their place to my two variables. Is Hadrian's favourite slightly pouting his lips, or has he simply got such lips? Given our sensitivity to nuance in such matters the interpretation here will in fact alter the expression.

A glance at the history of physiognomics may help to clarify

[22] Ferdinand Laban, *Der Gemütsausdruck des Antinous* (Berlin, 1891). I have attempted to document the wide range of interpretation of works of art in "Botticelli's Mythologies," *Journal of the Warburg and Courtauld Institutes* VIII (1945), 11–12, reprinted in *Symbolic Images* (London, 1972), pp. 204–6; and in "The Evidence of Images," Singleton, ed., *Interpretation,* as quoted above, note 21.

this discussion a little further. Originally physiognomics was conceived as the art of reading character from the face, but the features to which it paid attention were exclusively the permanent traits. Ever since classical antiquity it had mainly relied on the comparison between a human type and an animal species, the aquiline nose showing its bearer to be noble like the eagle, the bovine face betraying his placid disposition. These comparisons, which were first illustrated in the sixteenth century in a book by della Porta,[23] certainly influenced the rising art of portrait caricature because they demonstrated the imperviousness of physiognomic character to a variation of elements. A recognisable human face can look strikingly "like" a recognisable cow.

There is no doubt that this pseudo-scientific tradition relies on a reaction which most of us have experienced. In one of Igor Stravinsky's less charitable conversations he talks of "a worthy woman who naturally and unfortunately looked irate, like a hen, even when in good humour."[24] One may quarrel whether hens look irate, maybe peevish would be a better word here, but no one would easily deny that they have an "expression" which an unfortunate woman may share. In terms of our first approximation we may say that the permanent shape of the head (p) is interpreted in terms of a mobile expression and that this is the psychological root of the physiognomic superstition.

Humourists will always exploit this tendency of ours to project a human expression into an animal's head. The camel is seen as supercilious, a bloodhound with its wrinkled forehead looks worried, because if we were supercilious or worried our features would arrange themselves in this way. But here as always it is dangerous to equate inference or interpretation with a deliberate intellectual analysis of clues.[25] It is precisely the point that we respond to such configurations more or less automatically and involuntarily though we know perfectly well that the poor camel cannot help its supercilious looks. So deep-seated and instinctual is this response that it

[23] G. B. della Porta, *De humana Physiognomia* (1586).

[24] Igor Stravinsky and Robert Craft, *Themes and Episodes*, (New York, 1966), p. 152.

[25] See Paul Leyhausen, "Biologie von Ausdruck und Eindruck," in Konrad Lorenz and Paul Leyhausen, *Antriebe tierischen und menchlichen Verhaltens* (Munich, 1968), especially pp. 382 and 394.

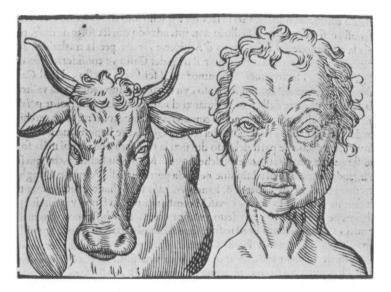

F<small>IG</small>. 30. *Physiognomic Comparison*, after G. B. Porta, 1587

pervades one's bodily reactions. Unless introspection deceives me, I believe that when I visit a zoo my muscular response changes as I move from the hippopotamus house to the cage of the weasels. Be that as it may, the human reaction to the permanent features of non-human physiognomies which is so well documented in fables and children's books, in folklore and in art suggests very strongly that our reaction to our fellow creatures is closely linked with our own body image. I am here led back to the old theory of empathy which played such a part at the turn of the century not only in the aesthetics of Lipps and of Vernon Lee but also in the writings of Berenson, Wölfflin, and Worringer. This doctrine relies on the traces of muscular response in our reaction to forms; it is not only the perception of music which makes us dance inwardly, but also the perception of shapes.

Maybe the idea dropped out of fashion partly because people got tired of it, and partly because it was too vaguely and too widely applied. But as far as the perception of expression is concerned I personally have no doubt that our understanding of other people's facial movement comes to us partly from the experience of our own. Not that this formulation solves the mystery which lies in the fact

that we can imitate an expression. How does the baby which responds to its mother's smile with a smile translate or transpose the visual impression sent to its brain through the eyes into the appropriate impulses from the brain to move its own facial muscles in a corresponding way? I suppose the hypothesis would hardly be gainsaid that the disposition to perform this translation from sight to movement is inborn. We do not have to learn smiling in front of a mirror, indeed I would not be surprised if the varying styles of facial expression we all can observe in different nations and traditions were transmitted from generation to generation or from leader to follower by unconscious imitation, by empathy. All this tends to corroborate the hypothesis that we interpret and code the perception of our fellow creatures not so much in visual but in muscular terms.

It may seem somewhat perverse to approach this far-reaching hypothesis by way of our freakish response to the imagined expression of animals, but this would not be the only case where a malfunction has helped to reveal a psychological mechanism. We obviously were not endowed with our capacity for empathy in order to read the souls of the beasts, but to understand our fellow humans. The more they resemble us the more likely will we be able to use our own muscular response as a clue to understanding their moods and emotions. This resemblance is necessary precisely because we will go wrong if we cannot separate our two variables. We must know from experience and perhaps from inborn knowledge what is a permanent trait and what an expressive deviation.

But would this hypothesis help us also to solve the main problem we are after, the detection of that physiognomic constancy which we called the characteristic expression of a person and which Petrarch described as the *aria*? I think it may, if we are ready to amend our first approximation which only recognised the two variables of the permanent and the mobile traits. Once more we may here hark back to the history of physiognomics to gain a leverage. When the crude superstition of animal physiognomics first came under fire in the eighteenth century, its critics, notably Hogarth and his commentator Lichtenberg, rightly stressed the second of my variables.[26] It is not the permanent traits which allow us to

26 For these discussions, see Ernst Kris, "Die Charakterköpfe des Franz Xaver Messerschmidt," *Jahrbuch der kunsthistorischen Sammlungen in Wien*, 1932.

read a character but the expression of emotions. But these mobile expressions, so they argued, gradually mould a face. A person who is frequently worried will acquire a furrowed brow, while a gay one will acquire a smiling face because the transient will pass into permanence. There is something, perhaps, in this commonsense view but it savours too much of eighteenth century rationalism to be fully acceptable. Hogarth, in other words, regards the face in the same light as Locke regards the mind. Both are a *tabula rasa* before individual experiences write their story onto its surface. It would certainly never be possible to arrive from such a view at an explanation of physiognomic constancy. For what this account omits is precisely the object of our quest, whether we call it character, personality, or disposition. It is this all-pervasive disposition which makes one person more prone to worry and another more likely to smile—in other words, every one of these 'expressions' is embedded in an over-all mood or feeling tone. There is a difference between the smile of an optimist and that of a pessimist. Needless to say, these moods in their turn are subject to fluctuations, some are reactions to external events, some reflect inner pressures. But we now begin to see in what respect the two variables of our first approximation were too crude. They failed to take account of the hierarchy that extends from the permanent frame of the body to the fleeting ripple of a mobile expression. Somewhere within this hierarchic sequence we must locate what we experience as the more permanent expression or disposition that constitutes for us such an important element in the "essence" of a personality. It is this, I believe, to which our muscular detector is so suited to respond, for in a sense these more permanent dispositions are probably muscular in their turn.

Once more we may remember that the link between "character" and body build belongs to an age-old belief in human types and human "complexions." If these beliefs do so little justice to the variety and subtlety of human types, this is at least partly due to the poverty of linguistic categories and concepts for the description of the inner as opposed to the external world. We just have no vocabulary to describe the characteristics of a person's attitudinal framework, but that does not mean that we cannot code these experiences in any other way. What is so characteristic and distinctive of a personality is this general tonus, the melody of transition from

given ranges of relaxation to forms of tenseness, and this in its turn will colour a person's speed of reaction, gait, rhythm of speech, and account for instance for that link between personality and handwriting we all feel to exist, whether or not we believe that it can be specified in words. If our own internal computer can somehow integrate these factors in a corresponding state we would know where to look for that invariant that normally survives the changes in a person's appearance. Here, in other words, we may have to look for that unwritten and unwritable formula which links for us Bertrand Russell at four and at ninety, for behind all these variations we sense a common signature tune. It is the same alertness, the same degree of tension and resilience we sense in both positions, and it is this which evokes in us the unique memory of that particular person. In a way, perhaps, the inability of many people to describe the colour of a person's eyes or the shape of a nose however well they may know him, constitutes a negative confirmation of this role of empathy.

If this hypothesis could be established, the same unity of response might also account for the experience of likeness in portrait and caricature across the variations and distortions we have observed. Indeed we may now be in the position to return to that paradigm of the caricaturist's trick which I discussed but did not explain in *Art and Illusion*.[27] It is the famous pictorial defence by the caricaturist Philipon who had been fined 6,000 F for having lampooned King Louis Philippe as a *poire*, a fathead, and pretended to ask for which step in this inevitable transformation he was to be punished? Though reactions of this kind are not easily verbalised it may still be possible to describe the likeness that is felt to exist between these stages in muscular rather than in purely visual terms.

Take the eyes which radically change their size, position, and even slant from the first picture to the last. Clearly by moving them together and increasing their steepness they are made to take over also the indication of the frowning forehead which increases in the third picture, only to be omitted as redundant in the last where we are made to feel the frown in the evil eyes of the *poire*. Regarding them as pointers for muscular movements, we can imagine ourselves

[27] See *Art and Illusion*, loc. cit.

LES POIRES,

Faites à la cour d'assises de Paris par le directeur de la CARICATURE.

Vendues pour payer les 6,000 fr. d'amende du journal le *Charivari*.

(CHEZ AUBERT, GALERIE VERO-DODAT)

Si, pour reconnaître le monarque dans une caricature, vous n'attendez pas qu'il soit designé autrement que par la ressemblance, vous tomberez dans l'absurde. Voyez ces croquis informes, auxquels j'aurais peut-être dû borner ma défense :

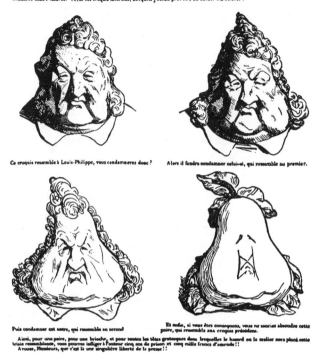

Ce croquis ressemble à Louis-Philippe, vous condamnerez donc ? Alors il faudra condamner celui-ci, qui ressemble au premier.

Puis condamner cet autre, qui ressemble au second

Et enfin, si vous êtes conséquens, vous ne sauriez absoudre cette poire, qui ressemble aux croquis précédens.

Ainsi, pour une poire, pour une brioche, et pour toutes les têtes grotesques dans lesquelles le hasard ou la malice aura placé cette triste ressemblance, vous pourrez infliger à l'auteur cinq ans de prison et cinq mille francs d'amende!! Avouez, Messieurs, que c'est une singulière liberté de la presse!!

FIG. 31. Charles Philipon, *Les Poires*, in *Le Charivari*, 1834

achieving this expression of the last phase only by knitting our brows and dropping our cheeks which corresponds to the feel of sluggish malice that belongs to the face from the first. The same is true of the corners of the mouth. In the first picture the mouth still smiles, but the heavy flesh pulls the sides down and creates a response in us—or at least in me—which is perfectly evoked by the scrawled features of the last picture, from which all traces of a false bonhommie have disappeared.

This role of our own bodily reaction in the experience of

equivalence may also help to account for the outstanding feature of caricature, its tendency to distortion and exaggeration: for our inner sense of dimensions differs radically from our visual perception of proportion. The inner sense always exaggerates. Try to move the tip of your nose downward and you will feel you have acquired a very different nose while the actual movement you achieved was probably no more than a fraction of an inch. How much the scale of our internal map differs from that of the eye is best (and most painfully) experienced at the dentist's when the tooth he belabours assumes rather gigantic proportions. No wonder the caricaturist or expressionist who relies on his inner sense will tend to alter the scales; he can do so without impairing the sense of identity if we can share his reactions in front of the same image.

Such a theory of empathy or sympathetic response does not preclude the misunderstanding of expressions. On the contrary, it helps to explain it. If Louis Philippe had been a Chinese, the slant of his eyes would have meant something different, but empathy might also have let us down in interpreting its exact nuance.

No doubt empathy does not offer a total explanation of our physiognomic reactions. It may not account for the impression of a narrow forehead as a sign of stupidity, nor is it clear whether this particular response is acquired or inborn, as Konrad Lorenz has postulated other physiognomic reactions to be.[28]

But whatever the limitations of the hypothesis here put forward, the student of art can at least contribute one observation from the history of portrait painting which strongly suggests that empathy does play a considerable part in the artist's response—it is the puzzling obtrusion of the artist's own likeness into the portrait. When the Prussian ambassador to England, Wilhelm von Humboldt, was painted by Sir Thomas Lawrence in 1828, his daughter reported after a visit to the master's studio that the upper half of the face, forehead, eyes and nose were much better than the lower half which was much too rosy and which, by the way, resembled Lawrence, as (she found) did all his portraits.[29] It may not be easy

[28] For a summary and illustration, see N. Tinbergen, *The Study of Instinct* (Oxford, 1951), pp. 208–9.

[29] Gabriele von Bülow, *Ein Lebensbild* (Berlin, 1895), p. 222. For the same tendency, see also my paper "Leonardo's Grotesque Heads," in A. Marazza, ed., *Leonardo, Saggi e Ricerche* (Rome, 1954).

at this distance of time to test this interesting observation, but the situation is different with a great contemporary master of portraiture, Oskar Kokoschka. Kokoschka's self-portraits testify to his grasp of his essential features, the face with its long distance between nose and chin. Many of Kokoschka's heads have these proportions, including his impressive portrait of Thomas Masaryk whose photographs show a different relation between the upper and the lower half of the face. Objectively, therefore, the likeness may be faulted, but it may still be true that the same power of empathy and projection which is here at work also gives the artist special insights which are denied to artists who are less involved.

It is not frequent for an art historian to be in the position of offering supporting evidence for such a general hypothesis, but it so happens that I had the privilege of listening to Kokoschka when he spoke of a particularly difficult portrait commission he had received some time past. As he spoke of the sitter whose face he found so hard to unriddle he automatically pulled a corresponding grimace of impenetrable rigidity. Clearly for him the understanding of another person's physiognomy took the way over his own muscular experience.

Paradoxically this involvement and identification here exerts the opposite pull from that we observed in the recognition and creation of types. Here it was the deviation from the norm, the degree of distance from the self that was found decisive. The extreme, the abnormal sticks in the mind and marks the type for us. Maybe the same mechanism operates in those portrait painters who are quick in seizing a characteristic trait without seeking much empathy. These would not be self-projectors like Kokoschka, but rather self-detachers or distancers (if there is such a word), but both of them could pivot their art on their self.

The very greatest of portrait painters probably must have access to both the mechanisms of projection and differentiation and have learnt to master them equally. It surely is no accident that a Rembrandt never ceased throughout his life to study his own face in all its changes and all its moods. But this intense involvement with his own features clarified rather than clouded his visual awareness of his sitter's appearance. There is an outstanding variety of physiognomies in Rembrandt's portrait œuvre, each of his portraits capturing a different character.

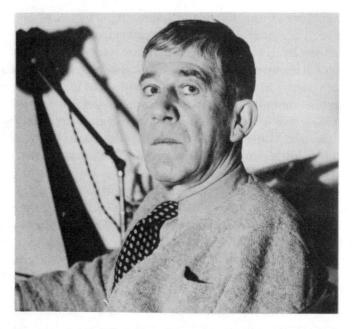

Fig. 32. *Oskar Kokoschka*, photograph, Press Association Ltd.

Should we here speak of character? One of the leading portrait painters of our own day once remarked to me that he never knew what people meant when they talked about the painter revealing the character of the sitter. He could not paint a character, he could only paint a face. I have more respect for this astringent opinion of a real master than I have for the sentimental talk about artists painting souls, but when all is said and done a great portrait—including some by that painter—does give us the illusion of seeing the face behind the mask.

It is quite true that we know next to nothing of the character of most of Rembrandt's sitters. But what has captivated art lovers who have stood in front of the greatest portraits of our artistic heritage is the impression of life that emanates from them. A surpassing masterpiece, such as Velazquez's great portrait of Pope Innocence X, never looks arrested in one pose, it seems to change in front of our eyes as if it offered a large variety of readings, each of them coherent and convincing. And yet this refusal to freeze into a

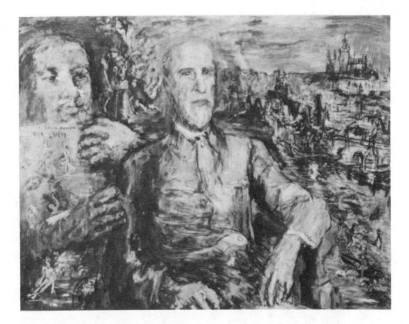

FIG. 33. *Thomas G. Masaryk*, by Oskar Kokoschka,
Pittsburgh Carnegie Institute

FIG. 34. *Thomas G. Masaryk*, photograph, 1935

43 THE MASK AND THE FACE

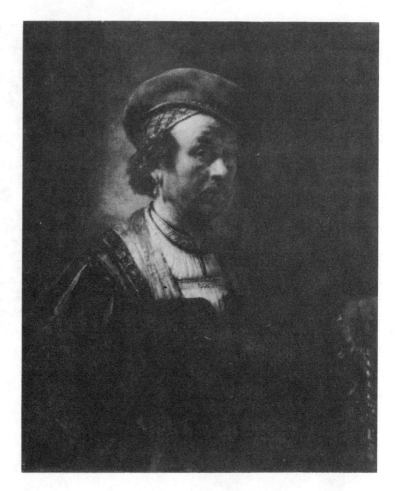

Fig. 35. *Rembrandt*, self-portrait,
Washington, D.C., National Gallery of Art, Widener
Collection

mask and settle into one rigid reading is not purchased at the ex-
pense of definition. We are not aware of ambiguities, of undefined
elements leading to incompatible interpretations, we have the illu-
sion of a face assuming different expressions all consistent with
what might be called the dominant expression, the air of the face.
Our projection, if one may use this chilling term, is guided by the
artist's understanding of the deep structure of the face, which

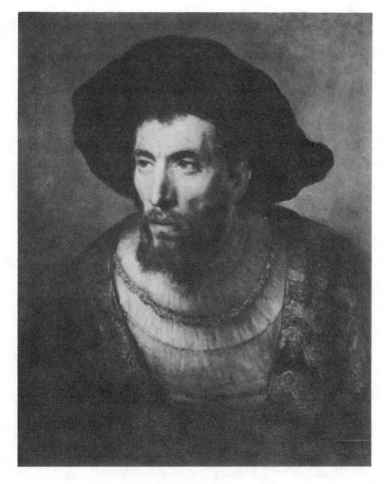

Fig. 36. *The Philosopher*, by Rembrandt,
Washington, D.C., National Gallery of Art, Widener
Collection

allows us to generate and test the various oscillations of the living physiognomy. At the same time we have the feeling that we really perceive what is constant behind the changing appearance, the unseen solution of the equation, the true colour of the man.[30] All

[30] What I wish to suggest, but cannot prove, is that Velazquez was able to solve the very problem which Orpen (quoted above, note 8) considered unsurmountable.

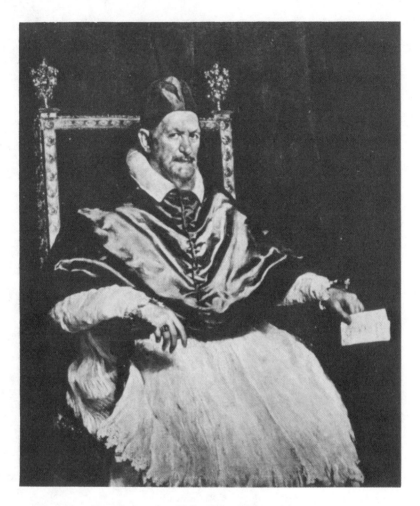

Fig. 37. *Pope Innocence X*, by Diego Velazquez,
Rome, Galleria Doria

these are inadequate metaphors, but they suggest that there may be
something, after all, in the old Platonic claim, so succinctly ex-
pressed in Max Liebermann's retort to a dissatisfied sitter—"this
painting, my dear Sir, resembles you more than you do yourself."

JULIAN HOCHBERG

the representation
of things
and people

The study of pictures and the study of psychology as a scientific inquiry have long been intertwined. As our understanding of the processes of perception and learning has increased, we have had to alter our view of how pictorial communication takes place; conversely, various pictures and sketches, ranging from the early experiments with perspective drawing, through the Gestaltists' explorations of the laws of grouping, to the inconsistent drawings of Escher and Albers, have had profound implications for the study of visual perception.

In this paper, I shall try to bring current perceptual theory to bear on some of the issues that have been raised in the context of pictorial theory. First, however, we shall go back to daVinci's early experiments on pictorial representations, and to the ways in which the two classical schools of perceptual theory dealt with the problems posed by those experiments. Leonardo offered the following method to discover the techniques by which pictures could be made:

This paper was written with the support of NICHHD Grant 5-R01-HD04213.

"... place a sheet of glass firmly in front of you, keep the eye fixed in location and trace the outline of a tree on the glass.... Follow the same procedure in painting... trees situated at the greater distances. Preserve these paintings on glass as aids and teachers in your work."

One of the reasons why Leonardo's window becomes a picture is because the pane of glass (Figure 1a,c), if perfectly prepared, would provide the eye with much the same distribution of light as would be produced by the scene itself (Figure 1b), and it is on the basis of the light reaching our eyes that we learn about the surfaces and distances in the world around us. This is one way of making a picture, then, if we define a picture as a flat object with a pigmented surface whose reflectance varies from place to place, and which can act as a substitute or surrogate for the spatial arrangement of an entirely different set of objects.

In effect, when viewed from the same position as that at which the painter stood when he traced the scene, one of Leonardo's windows is a surrogate for the scene simply because it affects the viewer's eye in a way that is similar to that in which the scene itself

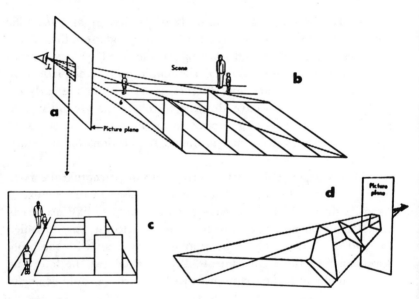

Fig. 1.

does. Now, such pictures will not always cause us to see tridimensional depth, but then we will not always correctly perceive the nature of a real three-dimensional scene, either, if that scene is itself viewed with a fixed head from one position in space. But by examining the pictures produced by this method (or by functionally analogous but more sophisticated procedures) that do successfully portray depth, Leonardo took note of almost all of the depth and distance cues that can be utilized by the painter. That is, he noted those characteristics`of the painted window that seemed to occur in conjunction with differences in the distance—characteristics that in fact would seem of necessity to occur frequently whenever one traces the projection of a three-dimensional world onto a two-dimensional surface.

The implications of this "experiment"—and of the prescriptions that follow from it—have been much debated. (Gibson, 1954, 1960; Gombrich, 1972; Goodman, 1968; etc.). I believe that the extreme positions that have been taken in this controversy, and in fact the debate itself, are rooted in an erroneous assumption. This is the assumption, usually implicit and unrecognized, that a single domain of perceptual operation is involved in the processing of visual information, and that a single set of rules will explain the relationship between the stimulus that confronts the eye and our perception of the scene.

This argument has centered mainly around one of the depth cues—*perspective*—and has come to rest heavily on this point: the pattern on the picture plane produces the same distribution of light and shade at the eye as does the original scene *only* when the observer regards the picture from the same viewpoint and from the same distance as that at which the picture was traced. Under these conditions the picture should in principle produce the same experience as does the scene itself. The problem arises for four reasons:

1. Why is only one scene represented by a picture?

The picture, on the one hand, and the scene, on the other, can both produce the same pattern of light at the eye. This fact is an example of a very familiar and very general statement: there are

infinitely many objects that can produce the same two-dimensional distribution of light.

It is also true, therefore, that there are infinitely many collections of objects and surfaces and distances that can be represented by any given picture, regardless of whether or not that picture is being viewed from the proper station point (Figure ld). However, in most cases we see each picture as representing only one (or two) scenes, and because an infinity of scenes *could* be perceived, but only one *is* perceived, this means that we must consider more than the stimulus itself: we must consider the nature of the observer, who only responds to the picture in that one of the many possible ways. This is a good point at which to see how each of the two classical schools of perceptual psychology deals characteristically with this problem:

The classical perceptual theories. The older version, which we may call "structuralism" in order to identify it later on, was an *empiricist* theory: it asserted that the fact that we see the football field stretching into the distance, in Figure 1, rather than the upright trapezoid, must be the result of our having learned to assume that things are square, that lines are parallel and not converging, etc. More specifically, this explanation proposed that our visual experiences consist of (i) *sensations* of different colors—light, shade, hue—and (ii) *images*, or memories of those sensations. Neither in viewing a scene itself, nor in viewing the object that we call a picture, are there any direct *visual* experiences that relate to the spatial characteristics of the scene. Space, it was contended, is a non-visual idea, a *tactual-kinesthetic* idea (composed of the memories of touch and of muscle-action) which our past experiences have taught us to associate with the visual depth cue. By careful analysis of the scene when we look at it, we note that we can indeed see the depth cues themselves—i.e., we can see that the lines converge—and we can note that there is no direct knowledge of space. This kind of observation makes the theoretical position plausible. It is also an example of introspection, that is, of the examination of our experience in order to identify its components, and what I can only call the causal relations between those components.

Aspects of this approach can still be found in uncritical analyses of the art of pictorial representation: for example, I see this object as being further away *because* the perspective lines appear to

be converging; I see this object as larger, *because* it appears to be further away; I see this man as angry *because* I see him scowling. Let us say right now that whether or not we really must learn to react to spatial differences (and there is good reason to doubt whether that is universally and necessarily true), there is one feature of structuralism that has clearly been discarded in psychology: it is the assumption that we can, by introspection, identify the elementary components of experience, and that we can observe their causal interaction.

Because we cannot now accept conclusions based on introspection, much of what goes on in art theory—and esthetic criticism—is on very dubious ground indeed. (This is why Gombrich's emphasis on artistic *discovery*, rather than insight, is particularly salutary.)

Structuralism, then, considered all *depth cues* to be symbols: the results of learned associations that have been formed between particular patterns of visual sensations and particular tactual-kinesthetic memories. What makes each of the depth cues effective (Figure 1c) is merely the fact that it has been associated with the other depth cues, and with movement, touching, etc., in the prior history of the individual.

When we try to predict specifically what a particular picture will look like, whether it will in fact successfully portray the scene or object that it is supposed to represent, structuralism is not particularly useful. Here, it was *Gestalt theory*—the second of the classical perceptual approaches—which seemed to offer the more attractive account of the relevant processes. Instead of viewing perceptual experience as composed of individual, isolable sensations of light, shade, and color—sensations to which images or memories of prior experiences become associated—Gestaltists proposed a "field theory": each pattern of light stimulation which falls on the retina of the eye presumably produces a characteristic process in the brain, a process that is organized into overall fields of causation and that changes with each change in the stimulus distribution. Individual sensations are not determined by the stimulation at any point in the visual display (and in fact are not really to be observed in perceptual experience). In order to know what some stimulus pattern (e.g., any picture) will look like, therefore, we have to know how the observer's underlying brain fields will organize themselves in

response to that pattern. In general, the brain fields will (presumably) organize themselves in the simplest (most economical) way possible, and knowledge of this fact permits us to predict how any picture will be perceived. Particular rules of organization can be extracted: for example, that we will see those shapes that are as symmetrical as possible (e.g., x rather than y in Figures 2a(i), (ii), the "law of symmetry"); that we will tend to see lines and edges as uninterruptedly as possible (e.g., we see a sine wave and a square wave in Figure 2b(i), rather than the set of closed shapes shown in black at ii: the "law of good continuation"); that we will tend to see things that are close together as belonging together (the "law of proximity"; Figure 2d). We experience tridimensionality when the brain-field organization that is produced by a given stimulus distribution on the retina is simpler for a tridimensional object than it is for a bidimensional one. Thus, in Figure 2c(ii) we see a flat pattern rather than a cube because we would have to break the good continuation of the lines in order to see the latter; in Figure 2c(i), the situation is reversed, and we see a cube. In Figure 2e, we see a dissection of the depth cues that had been identified in Figure 1. Note that in each case, the three dimensional arrangement that we can see (iii) is simpler than the two dimensional one (i), and it is (presumably) because the brain processes also are simpler in three-dimensional organization in these cases that these patterns act as depth cues. In short, to Gestalt theory, whether or not the depth cues are learned, they are not arbitrary, nor do they in any sense depend on memories of past tactual and kinesthetic experiences. What we see depends on the organizational characteristics of the brain field.

Arnheim is probably the chief exponent of this viewpoint today, in art theory. In perceptual psychology proper, exceedingly little adherence can now be found for the general approach, and the idea of "brain fields" as an explanatory principle seems to be just about totally defunct. The "laws of organization," however, may still turn out to be gross but useful prescriptions for designing pictures so that they will be comprehended as we want them to be comprehended—although we should note that these "laws" have never been adequately formulated nor measured as objective and quantitative rules.

These are the two major classical theories of perception and they have had their effects on theoretical discussions of art and pic-

torial representation. The last decade has seen vigorous and at least partially successful attempts to combine positive features of both of these classical approaches, and it will be to one such class of theory, and its relevance for pictorial representation, that we shall return. But first, let us continue with the other problems that are raised by Leonardo's experiment, and with which any adequate theory will have to cope.

FIG. 2.

2. Resistance of pictures to perspective distortions; tolerance of inconsistencies

The second problem with taking Leonardo's window as the prescription for making good pictures, is this: pictures can be viewed from one or the other side of the proper point, or from another viewing distance, without destroying their efficacy as pictures, and without offensive distortion (or even distortion that is noticeable) being reported. When viewed from an incorrect position, of course, the picture can no longer offer the same light to the eye as did the scene being represented: it now coincides with the light that is produced by a different "distorted" family of scenes (Figure 3). Nevertheless, it is frequently asserted that pictures can be viewed from various angles without any perceptual distortion. And, although I do not believe that such sweeping statements have any experimental support, it does seem to be quite clear that one can view pictures in an art gallery, or on the pages of a book, from viewpoints that are quite different from the proper point (the projection center i in Figure 1a) and not experience a noticeably distortion of the represented scene. In fact, as a loose corollary to this, we shall soon see that adherence to correct perspective is not always sufficient in order for things to look right. An even more telling point in this connection is that the discrepancy between the light produced by the picture and the light produced by the scene, itself, becomes even more drastic as the observer moves with respect to the picture. If he moves his head with respect to the *scene* itself, objects in the observer's field of view will shift their relative positions in accordance with the geometry of *movement parallax*; on the other hand, the parts of a *picture* retain their relative positions unchanged, lying as they do on the same plane. Because movement parallax is traditionally the strongest of all depth cues, it would seem that the picture as normally viewed (i.e., by the reader of a book or by the viewer in a gallery) must bear only a conventional and essentially arbitrary relationship to the scene being portrayed. For these reasons, and for others that we shall consider shortly, it has been strongly argued that the use of linear perspective must be considered an arbitrary, learned convention—a "language of vision" invented by Western painters and accepted by dint of Western viewers' experience with perspective paintings. This argument receives

some support from the fact that natives who have had little or no contact with Western pictures appear to be unable to interpret pictorial perspective; however, we should note that in such cases the perspective in question was conveyed by sketchy outlines, in pictures of very problematic fidelity. Even if it should prove true that the efficacy of such minimum sketches does indeed depend on the viewer's pictorial sophistication, that would not mean that the same would necessarily be true of more detailed and finished representations.

And the argument that grows out of the fact that we normally view pictures from some angle must also be rejected: Whether or not perspective is learned, it is in no sense arbitrary, and the fact that pictures can be accepted as representations of scenes even when they are viewed from an inappropriate station point has other explanations that are both plausible and interesting:

a. Shapes and extents are usually determined more by the framework in which they appear than by the image that they present to the eye. Because the distortions that result from any displacement in viewpoint are imposed equally on the frame and on the major lines within the picture, as well as on any particular shape within the picture, the shape/frame ratio remains intact. The apparent shapes of building facades, arches, etc., should then also remain unchanged to the degree that framework is important in shape and size perception.

b. We don't really know how much perceptual distortion does indeed result from changing the viewpoint: In 1972 Gombrich suggested (and there is independent experimental evidence to support him) that distortions *do* appear in pictures that are viewed from an improper stationpoint. When viewed from a slant, for example, the square facade on a pictured building may indeed continue to "look square," but its apparent slant toward the observer changes. This means that the scene that is being portrayed has changed, of course, in that the relative orientation between its parts have changed. Gombrich observes that the parts of a pictured scene do indeed appear to move and deform in their spatial relationships as the viewer moves relative to the picture—if the viewer pays close attention to these details. These changes are simply not noticed under normal conditions, which is part of the

more general problem of *attention*, to which we shall have to address ourselves shortly.

Such distortions of the represented scene can, of course, be made noticeable by increasing their magnitude sufficiently. The perspective inconsistencies of a de Chirico are immediately evident Also, the projection of the cube in the slanted picture plane in Figure 3b is clearly distorted if the picture is viewed normally (Figure 3f), whereas it becomes an acceptable cube if it is viewed from the central projection point (Figure 3a).

A closely related issue arises when we discuss the accuracy of projections of regular objects, like cubes. Consider the two cubes shown in Figures 3d and 3e: They cannot truly be pictures of cubes, although they may at first be taken as such: If they were indeed the projections of cubes, they would, of course, display some degree of linear perspective, as in 3g.

This fact has been used to support the argument that perspective representations are really only arbitrary conventions: If we are

FIG. 3.

willing to accept the parallel lines of Figures 3c,d,e as *perspective*, then it must be as a mere convention that we do so—or so the argument runs. But this argument may rest on a false premise. Suppose the objects pictured in Figures 3c,d,e are not cubes, but are instead truncated pyramids whose sides *diverge* away from the observer, and whose further face is larger than the nearer face. Perspective convergence then would just balance each object's divergence, and Figures 3c,d,e are thus perfectly good pictures. They are pictures of truncated pyramids, rather than of cubes, and we simply don't notice that fact. Far fetched? Consider Figure 3h, in which the distance between the front and back face has been increased, making the effect more noticeable.[1]

The object in Figure 3h can be seen in either of the two orientations shown in Figures 3c and 3e. When the object changes its apparent orientation, the two faces appear to change their relative sizes also, with the nearer face always the smaller. There is thus a *coupling* between perceived size and perceived distance: with a given pattern of lines confronting the eye, if the apparent distances change, the apparent sizes, angles, etc., also change correspondingly. (This is the clearest example of "perceptual causation" that I know, in which one aspect of what one perceives—i.e., orientation—seems to determine other aspects of what one perceives—e.g., size. And as such, it offers one of the few exceptions to the inutility of introspection: in this class of situations, it is meaningful to say, "X appears larger than Y *because* the cube appears to be oriented with side X further away than Y.") In structuralist terms, this coupling occurs because we make unconscious inferences, that is, because we have built up strong perceptual habits in the course of our experience with the world.

In any case, however, we see that the fact that such nonconvergent perspectives as those of Figures 3c,d,e produce impressions of pictorial depth does not necessarily mean that linear perspective (and pictorial depth, for that matter) are arbitrary artistic conven-

[1] There are several reasons why the effect might be expected to be more striking in Fig. 3h than in Fig. 3d: Thus, in 3d, it is harder to overlook the fact that faces *i* and *ii* are of equal size on the printed page, because the lines that describe their edges fall simultaneously within the clear *foveal* region at the center of the retina; again, because the front-to-back distance is increased in Figure 3h, the amount of divergence needed to compensate for perspective convergence is also greater; etc.

a

FIG. 4.

tions. Instead, such *non*convergent perspective drawings may be viewed as perfectly good *convergent* perspective drawings: drawings of objects whose sides diverge instead of being parallel.

Moreover, it is not safe to say that depth is portrayed as well by the nonconvergent perspective of Figure 3d as it is by the convergent perspective of Figure 3g, and that therefore both pictures rely equally on an arbitrary convention: as we adjust the angles and sides of the cube to make its representation consistent with the rules of perspective (making 3d into 3g), its apparent extension out of the picture plane and into the third dimension increases (Attneave and Frost, 1969). Thus, both aspects of the attempt to use nonconvergent-perspective pictures to prove that convergent perspective is merely an arbitrary convention, must be seriously questioned. The pictures may really be perceived as convergent-perspective pictures of divergent objects, despite the artist's intentions; and the pictured depth may in fact decrease, as the picture departs from being a true convergent-perspective projection of a true (nondivergent) cube.

Lest this rebuttal lead us to discard too much, let us note that

b **c**

it leaves us with the necessity of explaining why (and how) we can so often fail to notice that the objects portrayed in Figures 3c and e are not cubes, and why we can tolerate the inconsistencies that must arise between the parts of any accurate picture when it is viewed from any point other than the projection center. In fact, as Pirenne has pointed out (1970), inconsistencies must often be introduced in pictorial perspective if the picture is to look right. An example of this is the use of circles in Figure 4a, instead of the ellipses that would have been consistent with the rest of the perspective used in that painting. That our eye tolerates, and may even demand such inconsistency is a fact which makes Leonardo's window a poor model of what a picture is and how it works, regardless of whether or not perspective is a learned and arbitrary pictorial convention.

Let us attempt to account for why inconsistency is tolerated, by considering pictures with far greater amounts of inconsistency built into them.

Consider the inconsistent pictures of Escher, and of Penrose (Figure 4b). Two kinds of inconsistency are patent which are both revealed more clearly in Figure 4c.

I think that these pictures are truly important for understanding perceptual process. It is very hard to explain, in terms of any

Gestalt analysis, why they appear to be tridimensional: Gestalt theory, it should be remembered, would say that the pictures will look solid only if the organizations are simpler in three dimensions than in two. In order for the represented object to look tridimensional, however, the line that is continuous—*as a line*—at *x*, must in fact represent a *discontinuous* corner between two planes (i.e., a discontinuous dihedral angle). This is not the place to dissect out all of the implications of this sort of figure, but note these facts:

First, that the way in which the object appears to face depends on where one is looking (i.e., at *i* or at *ii*), and on the local depth cues that one finds there.

Second, that the tridimensional inconsistency between the two halves of the figure causes the figure neither to look flat, nor to appear to be broken in the middle, which tells us that the *good continuity* of a *line* (see Figure 2b) is a separate phenomenon from the *good continuity* of an *edge*. (I will argue later [pp. 71f.] that this is because the two—line and edge—reflect two different tasks that can be pursued by the perceptual system.)

Third, the nature of the inconsistency is not immediately evident when the observer peruses Figure 4b, or even when he glances at the inconsistent "frame" of Figure 4c, unless the two inconsistent parts are brought close together. This suggests that certain aspects or features of the object are simply not *stored* while the observer looks from one corner to the other.

In other words, the explanation of why inconsistencies of pictured space can go unnoticed, may in part be this: the inconsistent regions of the picture are not normally compared to each other directly. This brings us to a major point, almost completely ignored by Gestalt theory: any object is usually examined by a succession of multiple glimpses, and the various regions that are looked at each fall in turn on the same place in the eye. That is, the separate parts of the figure all have to be brought at different times to the central part of the retina, the *fovea,* if they are to be seen in full clarity of detail. Let us consider what this fact suggests about the perceptual process, and about the nature of pictorial representation.[2]

[2] In passing, let us note that this means that we simply cannot retain the Gestaltist's model of the nervous system, in which object properties are explained in terms of simultaneous interactions that occur within some hypothesized field within the brain.

It is evident that when we read a line of type, the action depends on the movement of our eyes, (Figure 5a), and that the same thing occurs when we look at a picture (Figure 6). From such successive glimpses, we must construct an integrated scheme that encompasses the whole scene. Mere persistance of vision is of course no explanation for the fact that we see a coherent picture, rather than a set of discrete views: Persistent vision would result only in the kind of superposition that we see in Figures 5b and 6c. Nor is successive vision merely a matter of having looked everywhere in the field, as does the scanning raster of a TV camera. The fact is that we do not look everywhere in the field, and the looking process is both an active and selective one. What we perceive of the world is determined therefore both by the processes that guide fixation, and by those that determine what we retain from a sequence of fixations.

These processes, in turn, depend on the observer's attention (and on his perceptual *intentions*), so that it is now evident that we cannot make a full accounting of pictorial representation in terms of Leonardo's window alone (nor in terms of any other analysis that restricts itself to discussions of the stimulation of the visual system). This is so regardless of whether or not we take Leonardo's depth cues to be mere pictorial convention.

3. Perception as a purposive behavior

A frequent criticism of the classical perceptual theories was that they ignored the purposive nature of perception (Brentano, 1924; Brunswik, 1956; Bruner, 1957) and in examining perception with a view toward remedying this deficiency it will be helpful to

The reader's eye samples the text by successive glances

a

b

Fig. 5.

a b

c

Fig. 6.

consider first some of the main characteristics of purposive behaviors in general.

Analyses of skilled sequential behaviors (whether they be maze learning, skilled motor acts like typing or piano-playing, or language production and perception) all suggest the existence of guiding structures: of "expectations," "cognitive maps," or "deep structure." From such cognitive structures, quite different specific detailed response sequences may be generated, all of which are equivalent only in that they produce the same end result. There is a long and continuing argument to this point that recurs at various junctions in psychological theorizing (cf. Tolman, 1932; Miller et al., 1960). I add here only that *most or all visual perception also involves highly skilled sequential purposive behaviors,* and that some large component of the perceptual process in the adult is best understood in terms of the "expectations" and "maps" that underlie these skilled behaviors.

Skilled purposive activities are run off in accordance with organized plans, and their progress must be tested at appropriate points. That is, although such acts may initially consist of individual, more-or-less simple responses to individual stimulus situations, a very different kind of behavior emerges with continued practice: entire *sequences* of actions are run off smoothly, with no need for an external stimulus to initiate each act. Moreover, such sequences are not merely "chains" in which each response has become the stimulus or "trigger" that sets off the next response: in playing the piano, in typing, or in speaking, responses are executed with such rapidity, and the interval between any two successive responses is so short, that there simply is not sufficient time for the nerve impulse that arises from the response in one set of muscles to travel to the muscles that execute the next response (Lashley, 1951). What then determines the sequence of muscular actions—e.g., what makes the fingers strike the keys in one order rather than another, or coordinates the sequence of tongue and lip movements in one order rather than another?

It is clear that our nervous systems can generate, store, and execute what in a computer would be called a *program*— that is, a series of orders, or *efferent commands,* that go out from the central nervous system to the musculature, that can be run off in sequence. The possession of skill depends on having a working repertory of

such programs, such prearranged sequences of efferent commands. Such sequences have *goals*—i.e., states of affairs in the world that are to be brought about by these actions. This means that each program must also contain provisions for obtaining sensory information about the world at critical points in the sequence, and for comparing that information to some desired state of affairs. This function was filled by the "image" in structuralist psychology: in that view, behavior was guided by sensory images, so that both the thought that guides the act and the information that terminates it were held to consist of sensory experiences, and of memories of these.

In fact, there is no necessary implication of consciousness in such behaviors, any more than there is in the response of a thermostat that governs the behavior of an automatic heating system by sampling the temperature of the room.[3]

Note that such purposive behavior programs have several characteristics of present interest: they are *selective*, in that only certain specific aspects of the environment are relevant to them (e.g., the thermostat is built to respond mainly to temperature differences, and will usually be unaffected by musical notes). They are goal-directed, in that the programs are executed only in order to achieve some specific state of the world. These two characteristics will reappear under the names of *attention* and *intention* (those hitherto mysterious properties), when we turn to consider the behaviors that are specifically designed to gather information, i.e., the perceptual behaviors.

Perceptual behavior. How one casts his gaze around the world depends therefore both upon his knowledge of the world, and on his purposes—i.e., on the information that he seeks.

It is well known that we can only remember a small number of unrelated items in immediate memory—somewhere in the neighborhood of 5 to 7 items. In order to remember a larger number of items, they must be committed to more permanent storage in an encoded form (i.e., in an abstracted, reduced, or symbolic form.)

[3] That is, the program may be concerned with one or more kinds of information—e.g., photic (visual), phonic (auditory), thermal etc.—but that does not, by itself, require that the effective device (e.g., the heating system) have conscious images of visual, auditory, or thermal experience. All we can say is that the *dimensionality of an expectation* is given by the sensory modality against which it is checked. A program that is checked against one predominant modality will thus have the characteristics of being guided by one kind of imagery.

Because the succession of our eye movements is often quite rapid (about 4 per second), an observer will normally make more fixations during the inspection of a single scene than he can hold in his immediate memory. Some part of his perception of the scene therefore must draw on encoded recollections of his earlier glimpses. We must next inquire, therefore, how the separate glimpses are put together over time into a single perceived scene, and how they are retained over a series of many discrete glances.

Because our eyes register fine detail only within a very small *foveal* region of the visual field, we must learn about the visual world by a succession of glances in different directions. Such glances are made by *saccadic* eye movements, whose end-points are decided before the movement is initiated (i.e., saccades are *ballistic* movements): where one looks is decided in advance. Therefore, the content of each glance is always, in a sense, an answer to a question about what will be seen if some specific part of the peripherally-viewed scene is brought to the fovea. In viewing a normal world, the subject has two sources of expectations: (*i*) he has learned something about what shapes he should expect to meet with, in the world, and about their regularities; and (*ii*) the wide periphery of the retina, which is low in acuity and therefore in the detail that it can pick up, nevertheless provides an intimation of what will meet his glance when the observer moves his eyes to some region of the visual field.

The fact that looking at static pictures is a temporal process has always been evident to students of composition, who discuss "leading the eye" in some obligatory sequence over the layout of the picture. In fact, however, the actual *order* in which the parts of a picture are regarded is probably not well enforced under normal viewing conditions (cf. Buswell, 1935).

This freedom makes it difficult to begin our functional analysis of what we may call *active looking* (as opposed to passive or abstract staring) with the study of the skills that are involved in pictorial perception itself.

Let us therefore look first at the *reading skills*, in which the order of encoding is not free, but is enforced by the nature of language. These skills are acquired relatively late in childhood, moreover, so that we can examine their acquisition with relative ease (whereas many of the skills that underlie the perception of peo-

ple, objects, and events are probably acquired largely before the age at which we can profitably study infants). This is partly due to the arbitrary nature of the symbols that are used in reading. (This is a good point at which to forestall a misunderstanding: I am not equating reading with picture perception. The symbols of art are not, in general, arbitrary; they are not learned in the same sense that we learn to read; and while the concept of a "language of vision" is not meaningless by any means, it is sometimes used in a very misleading sense in drawing unjustified analogies between reading and pictorial perception.)

Reading text letter-by-letter, as a child must do when he decodes words whose pattern he has not yet learned to recognize, requires the reader to make many small adjacent fixations in a fixed sequence. This is probably a very unnatural way of using one's eyes, and quite contrary to the skills that we acquire in the cradle, and that we maintain throughout our active visual exploration of an extended three-dimensional world. Small wonder that the task of letter-by-letter reading is aversive.

The task can be made easier in various ways; most simply by printing in a very large type face, with a lot of space between the letters. But the best way is to outgrow the need for letter-by-letter (or even word-by-word) fixations.

Normal text is highly redundant in many ways, so that the subject does not have to look at every part of a letter clearly (nor at every part of a word) in order to know what is being said. In short, the subject will—and *should*—tend to "guess" at what is vaguely discerned in peripheral vision. The more he can correctly anticipate the message (by his knowledge of the spelling, grammar, idiom, and substance of the text), the more likely that his "guesses" will be right, and the fewer the fixations that he actually needs to make. But *knowledge* is essential: Training the reader to make fewer fixations can be of little use if his anticipations are and remain incorrect.

The skilled reader thus can largely relieve himself of the necessity of looking closely at the text, by responding with an entire word or phrase to the few features that he sees clearly in the foveal vision. He therefore needs to fixate only those parts of the text, further along the page, that will enable him to make new guesses

and to check his previous ones. His expectations of what he will find when he looks further along the page are based in part on the syntax and meaning of what he has just read. In order for sampling to be possible, and for anything less than letter-by-letter reading to suffice, some redundancy is therefore needed. Given the redundancy of connected discourse, the reader formulates and tests speech fragments, and he knows enough about the constraints of language to make a profitable guess at how much further along he should look next in order to test those fragments and to gain information to formulate new hypotheses. In addition, he can use the information given in peripheral vision to select the places at which he should seek successive stimulus input.[4] The better the reader, the more widespread can be the fixations by which he samples the text—just so long as the text provides him with contextual redundancy, and so long as his task permits him to attend to the meaning or content, rather than to attend to the spelling or to the shapes of individual letters. Note that the skilled reader does not simply look at a block of text and automatically apprehend its message. He must *intend* to read the display, must "pay attention" to its meaning by developing hypotheses about what the next string of symbols consists of, and by testing those expectations at appropriate places in the text further along. He must generate the material, at which he has not yet looked, on the basis of whatever fragments he has in fact seen. Any contents of his glances that were not anticipated in this fashion, and that were not encoded and stored as part of some such speech structure, will soon exceed the memory-span for such unorganized and independent material. We would expect therefore that a completely unfamiliar word or passage would soon be forgotten, whereas once the subject has identified the stimulus as being some one particular familiar word or phrase, he can generate all the individual letters in sequence whenever he is called upon to do so (assuming he can spell), regardless of the number of letters involved.

Let us now extend this analysis of an active, purposive, searching perceptual system, which we have examined in the context of

[4] For example, he should, by noting where the inter-word spaces fall in peripheral vision, be able to anticipate where he must look in order to fixate the most informative portions of words (i.e., their beginnings and ends) and he should be able to anticipate which words are likely to turn out to be articles and prepositions.

the reading process, into the much richer area of the visual perception of objects and space.

The first point to remember is that the array of stimulation that is presented to the eye from a picture (as from the scene itself) is not simultaneously available to the brain: only what falls within the eye's field of view is visible at all, and only what falls within the narrow span of the fovea is clearly visible. During a single glance at The Great Wave, in Figure 6, for example, the experience might be roughly like that obtained by looking at any one of the clear areas in Figure 6a. Successive glances will bring other parts of the picture into clear vision. These glances are not randomly distributed, but rather are directed to bring the most informative parts of the picture to the fovea (Buswell, 1935; Brooks, 1961; Pollack and Spencer, 1968). For example, Figure 6a shows the five most frequent fixations that subjects make when they look at that picture (according to Buswell's eye-movement records) and it is clearly a more complete sampling of the picture's content than are the five least frequent fixations (Figure 6b). As in skilled reading, therefore, where we direct our foveas when we look at pictures is guided by the hypotheses that are generated by what we see in peripheral vision. And also as in reading, the integration of the successive glimpses that we receive when scanning a picture must depend on our ability to fit each view into some "mental map," into a cognitive structure that stores the information that each glance brings, in a form that enables us to return our gaze to any part that we may wish to re-examine. A mere persistence of vision, a merely passive storage of the successive glimpses, will not do: it would result only in a superposition such as that of Figure 6c, as different regions of the picture fall successively on the same parts of the eye. Instead, each eye movement tests an expectation, and what we perceive of the picture is the map that we have actively fitted together from smaller pieces in this way.

"To apprehend a pattern is to discern the principle on which its elements are ordered. To see the elements only will not suffice, for the pattern does not reside in the elements . . . (but) in the rule which governs their relations to each other. . . . Stereotyped vision sees only those patterns which its stereotypes have permitted it to anticipate" (Taylor, 1964). This is the basis of visual integration, the "glue" by which successive glimpses are joined into a single

perceptual structure. If I have grasped the right "apprehended pattern," or *map*, my successive glimpses fit together into the perceptual structure so well that the stable form is easy to see and the component glances are difficult to detect. With no map (or with the wrong one), on the other hand, I have only momentary glimpses, erratic and disorganized.

So we see that at any given time most of the picture as we perceive it is not on the retina of the eye, nor on the plane of the picture—it is in the mind's eye (cf. Hochberg, 1968). And in that as-yet mysterious domain, the scene being portrayed is stored in encoded form, rather than as a mental mirror of the scene. What is in fact encoded, as well as how it is encoded, depends on the observer's task, on what he can anticipate and store, and on where he looks. Unfortunately, we know very little about what is encoded and stored in the process of putting together a picture in our minds out of successive glimpses. The violations of perspective consistency that we discussed earlier seem to show that we do not normally encode and store all the metric aspects of a scene. Moreover, from Figure 4c, we learn that—even within the span of a single object—what we do not encode and store is lost to perception.

It is here that our familiarity with the artist's discoveries of how to portray the world must have its greatest effect (and perhaps its only effect) on our perception of pictures. But although Gombrich's point that such conventions are *discoveries* appears to be widely accepted, there seems to be little recognition that discoveries are *not* inventions: i.e., that the conventions are not necessarily arbitrary, that the artist is not free to design just any old language of vision that strikes his fancy. Let us here consider the use of lines on paper, which has been advanced as strong evidence of the arbitrary nature of the "language of pictures." Lines, which are merely ribbons of pigment, will fulfill the following functions in pictorial representation: they will act as the edges of surfaces (Figure 7a), as a sharp corner or *dihedral* (Figure 7b[i]), as a rounded corner or *horizon* (Figure 7c[i]), etc. Now, a line on a piece of paper is really quite different from any of these edges and corners. So it certainly seems reasonable—at least at first glance—to assume that the use of lines for this purpose must be the use of an arbitrary convention. But the fact is that outline pictures are not, in principle, anything like a learned language: A nineteen-month-old child who had been

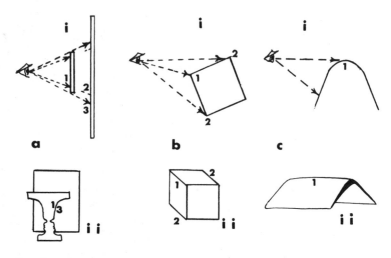

FIG. 7.

taught his vocabulary solely by the use of solid objects, and who had received no instruction nor training whatsoever concerning pictorial meaning or content (and indeed, had seen practically no pictures) recognized objects that were portrayed by two-dimensional outline drawings as well as photographs (Hochberg and Brooks, 1962). Thus, if the ability to understand outline drawings is entirely learned (and it may not be: it may be innate), the learning must occur not as a separate process, but in the normal course of whatever learning may be needed in order to see the edges of objects in the world. In line drawings, the artist has not invented a completely arbitrary language: instead, he has discovered a stimulus that is equivalent in some way to the features by which the visual system normally encodes the images of objects in the visual field, and by which it guides its purposive actions.

Let us speculate about how such "conventions" must be learned by experience with the world of objects. Consider a real object's edge: if you move your eye across it, there is an abrupt increase in distance past that point. This fact has very considerable consequences for oculomotor behaviors. As long as you intend to move your eye from one point to another, there are no adjustments that the eyes have to make other than the move itself. Moreover, if the eyes

are to fixate any point on the surface during or after the head has changed position, then the positions of all the points on the surface, right up to the objects' edge (Figure 7a[1]), are *determinate* (i.e., each of them can be fixated by some definite eye movement), whereas each change in the head's viewing position should cause the object's edge to change the part of the backround (Figure 7a[2]) that it hides from view. Thus, the *shape* (or set of fixatable positions) is determinate to one side of the object's edge, but not to both. Now these are the very figure-ground properties to which, as we have seen, the Gestaltists look for the new units of experience, and it seems very plausible in terms of the analysis that I have just described (cf. Hochberg, 1970, 1968) that these properties reflect, not the actions of "brain fields," but rather the existence of "expectancies" about the consequences of making eye and head movements while looking at an object's edge. Why do we have such expectancies? Because eye movements are programmed in advance of their execution (they are ballistic, remember). They must therefore be guided by expectations, based on peripheral vision, of what the fovea will confront. But why should such expectancies be aroused by lines on paper? Perhaps because much of the time that an edge between two surfaces appears in the visual field, it is accompanied by a brightness difference: that is, because of lighting, because of surface-texture differences, etc., a brightness-difference contour should provide a *depth cue* that can furnish guidance as to where in the periphery an object's edge will be found.[5]

This analysis, if it is taken seriously, contains at least two points that are of interest to our general discussion of pictorial representation. First, the efficacy of line drawings can tell us something about the ways in which we perceive and encode the world itself, not only

[5] But still—why *lines*, which are probably not, after all, the kinds of contour that we most frequently encounter? Perhaps the answer is this: There are structures in the visual nervous system that respond to the contour between regions of different brightness, and the same mechanisms probably respond to lines as well. And so, unless the viewer has had much more experience with lines on paper than he has had with the brightness-differences that arise at objects' edges, lines that fall in the periphery of his eye should serve as stimuli appropriate to objects' edges. This poses an interesting contrast to the more traditional proposal that our responses to line drawings are learned from pictures. From the present viewpoint, if we could really expose people to outline pictures of the world more than they are exposed to the world itself, the pictures would cease to "work" as representations.

about the art of pictorial representation. It is a possibility such as this, of course, that makes the study of pictorial art important to the perceptual psychologist.

But lines are merely part of the medium, as it were, and "artistic conventions" are much more matters of *pattern*. And for patterns, the only powerful generalizations still seem to be the "laws of organization" that Gestaltists demonstrated largely by means of line drawings. We can easily reach conclusions about the laws of organization that are similar to the conclusions we reached about outlines. First we note that the "laws of organization" are probably not merely arbitrary artistic conventions. The protective colorations by which animals camouflage themselves and render themselves invisible to predatory animals seem to depend on the same principles of organization that conceal familiar shapes from human eyes, and surely the predators have not been exposed to our artistic conventions (cf. Metzger, 1953). To the extent that such determinants of organization are learned, therefore, it must be chiefly by way of commerce with the objects in the real world. Next, let us see why the Gestalt "laws of organization" help us to perceive objects correctly, and might therefore be acquired (ontogenetically or phylogenetically) in the course of dealing with the world. We have noted that brightness-difference contours offer our peripheral vision cues to where the edges of objects lie. Of course, not all brightness-changes mark objects' edges, horizons, or corners. Some are caused by shadow, some are due to layers of pigment, etc. There are, however certain characteristics that tend to distinguish the brightness-differences that are produced by edges and corners. For example, it is very improbable in nature that the edges of two surfaces that lie at different distances from the observer will by chance be so oriented to his line of sight that they will form a single continuous contour in his visual field. A continuous contour is a good indication of an object's edge. It is not surprising, therefore, that we are very sensitive to discontinuities of contours (Riggs, 1965), and that we tend to organize our perceptions in such a way that continuous contours are seen as being the edge or corner of a single surface ("law of good continuation," already mentioned).

This is not to deny that the patterns by which we represent shapes in outline drawings are ambiguous, because they surely are: Figure 2c(*i*) can be seen as a heptagonal flat pattern, the line at Figure

7c(1) *can* be seen as a flat curve (instead of a hemicylinder's horizon), etc. This is not to deny that these means of portraying objects and space must be *discovered*: after all, lines and flat patterns are not themselves the objects that they are used to portray (and, as we have seen, introspection will not in general serve to identify for us the features in a scene that cause us to perceive it as we do). Nor is it to deny that these methods of representation are very low-fidelity surrogates, in that they do not project to the eye an array of light that is identical (or even closely similar) to that produced by the scene portrayed.

Nevertheless, their ambiguity does not make such drawings arbitrary: I can identify, say, Moshe Dayan, by a variety of stimuli: (1) by printing his name in type (which *is* arbitrary, and does not involve the same perceptuomotor plans that I use when I see his picture); (2) by drawing an eyepatch (which also is arbitrary as a label, but which does involve as well some of the visual features by which his face is encoded as a shaped object); (3) by a high-fidelity surrogate (a painting or photograph that offers the observer's eye the same light as Dayan does—surely nonarbitrary); or (4) by a drawing, which is composed of lines, and is distorted so as to make sure that we encode the drawing—a flat, static pattern of pigment —as a solid, mobile face. Far from arbitrary, this last method permits us to bypass the accidental patterns and textures that are presented to the eye from any specific viewpoint of the object itself, and to select only those features that the viewer will encode and store in ways that we want him to. This is, of course, most clearly exemplified in the process of deliberate *caricature.* In attempting to understand that process, the study of visual perception must set aside its reliance on purely geometrical analyses of stimulation, and start to confront the more refractory problems of how form, movement, and character are encoded and stored.

4. Caricatures of objects

Let us note first that caricatures, in the sense of pictures that capture the "essence" of some represented object, are not restricted to the portrayal of people or animals. In fact, it will be easier to approach the problem of what is meant by "capturing the essence"

if we examine first the caricaturization of objects' physical properties, in which "essence" is more readily described, and then return over the same ground in a discussion of the portrayal of such "nonphysical" properties as expression and character.

The two patterns in Figure 2c*i*, *ii* are both equally good (or equally bad) projections of a cube, but it is surely the case that Figure 2c*i* is closer to the *canonical form* of a cube—i.e., to the features by which we encode and remember cubes. It is hard to remember where and how the lines break, even while you are looking at Figure 2c*ii*, with every intellectual conviction that it is a cube. Figure 2c*i* has caught more of the "essence" of a cube. In this sense, most of the demonstrations by which Gestalt "laws of organization" were studied (and especially those in which reversible-perspective figures were employed) represent experiments on, and prescriptions for, the caricature of tridimensional objects. In general, however, more attention has been paid to camouflage—that is, to making objects harder to perceive—which is in a sense the inverse of caricature.

I know of only one experimental study directly concerned with caricature. Ryan and Schwarz (1956) compared four modes of representation: (a) photographs; (b) shaded drawings; (c) line drawings that were traced from the photographs, and thus were projectively accurate; and (d) cartoons of the same objects (Figure 8). The pictures were presented for brief exposures, and the subject had to specify the relative position of some part of the picture—e.g., the positions of the fingers in a hand. The exposures were increased from a point at which they were too brief, until they were sufficient for accurate judgments to be obtained, with this finding: Cartoons were correctly perceived at the shortest exposure; outline drawings require the longest exposures; and the other two were about equal, and fell between these extremes.

Why is the cartoon drawing correctly grasped at more rapid exposure than the high-fidelity photograph? The contours that have been retained, for one thing, have been "simplified." That is, smooth curves have been substituted for complex and irregular ones: information about the anatomy of the hand is lost in the process (the picture is thereby made more redundant); it now requires fewer fixations to sample it and to make predictions about unsampled portions; those features that have been retained require

FIG. 8.

fewer corrections to be applied to our encoded schemas (cf. Hebb, 1949; Hochberg, 1968), or canonical forms, of these objects. Moreover, the portrayed object is probably recognizable further out into the field of peripheral vision. For this reason also, fewer fixations are required, and these are probably executed with firmer expectations of what will be seen.

Although no one has actually tested the peripheral recognizability of these stimuli, the following reasons underlie the above assertions: (1) increasing the smoothness and redundancy of the curves in Figure 8d must increase the efficacy of peripheral vision, which is poor on small detail, and "noisy." (2) Wherever contours intersect in the cartoon drawing, the artist has deliberately rearranged them so that they meet at right angles; whether because of "good continuation," or as the depth cue of "interposition," this arrangement should make unambiguous to the observer which edge is the nearer one, perhaps even in peripheral vision. (3) Wherever the contours in the cartoon represent the boundaries of "holes" or

spaces, their relative separation has been increased. This in turn has two consequences: (a) each contour is more clearly separable from its neighbors, even in peripheral vision; (b) as we have seen, the factors of contour-proximity and enclosedness tend to make a region become figure (i.e., to be seen as object). Increasing the separation between two fingers, for example, increases the size of the regions which we are intended to see as empty space, and thereby keeps the spaces from being seen as objects.[6] (Note that the process that we have been talking about is the *inverse* of camouflage, in which the laws of organization are used to make objects seem like spaces and to make local pigmentation on one object look like other objects' edges.)

The caricature has thus been made better than the more accurate pictures by accentuating those distinctive features (cf. E. J. Gibson, 1969) by which the tridimensional nature of objects is normally apprehended. It seems plausible that as a particular caricature of an object is picked up and used by other artists (see Gombrich, 1956), the pattern *as a two dimensional design* may, by progressive simplification in passing through the eyes and hands of successive artists, entirely lose its projective relationship with the object. When that happens, we are left with only an arbitrary relationship between the symbol and its referent. But because the distinction between arbitrary symbol and a distorted, simplified caricature may not be a sharp one, this does not mean that the latter is just as arbitrary and as conventional as the former. Consider the differences between learning to read text and learning to "read" comic strips: very few children learn to read text of their own accord, i.e., without undergoing formal instructions and a great deal of paired-associates

[6] Here we may note one source of "esthetic value," in passing: It has been suggested over and over again, in visual art as in other art forms, that economy is a (or even *the*) cardinal virtue. Economy must be distinguished from *simplicity*, which we discussed earlier: One and the same pattern may be either more or less economical, depending on whether it is taken as representing a simple or a complicated object (cf. Figs. 2c*i* and *ii*). But for a pattern of given complexity, the more economical it is as a pictorial representation, the more satisfying it may be to recognize the object in the picture. This will interact with another source of satisfaction: Because simplicity of representation can be achieved in different ways, we can expect that different artists will find characteristically different ways of doing so; and the recognition of the artist's "signature" will help the viewer to perceive the represented object, and will also give some tangible value to this cultural expertise (i.e., to the ability to identify the artist).

learning (learning what sounds go with what graphic symbol). Comic strips, on the other hand, may contain many graphic symbols that are indeed arbitrary, but they must also have so many features which they share with the real world in a *nonarbitrary* fashion[7] that no formal education, nor paired-associates learning, is required: once the viewer grasps the nature of the idiom, no further instruction seems to be needed.

The problem with what I have just said, however, is this: What can the object that is portrayed in the caricature in Figure 8d have in common with the hand (i.e., the object that is accurately projected) in Figure 8a? Two possible answers apply here.

The first answer is one which we have already considered in passing, that various objects with which we are familiar have *canonical forms* (i.e., shapes that are close to the ways in which those objects are encoded in our mind's eye). Throughout history, for example, artists have tended to draw certain familiar objects from standardized positions. Pirenne has argued (as we noted) that the use of such shapes, whether or not they are appropriate to the perspective of the scene in which they are embedded, helps us to perceive the objects in undistorted form, even when the observer views the picture from some position other than the projection center. As I understand Pirenne's argument, when the observer automatically corrects for the slant of the picture's surface, the object being represented will quite naturally still be seen in its canonical form (because that is the way it is projected on that surface). Whether or not this particular explanation will survive quantitative experimental inquiry (to which it is susceptible, but to which it has not yet been subjected), the selection of canonical views—and the violation of projective fidelity in order to keep the views canonical—makes of each such picture a caricature of a scene. Why is the violation, the projective inconsistency, not noted by (or not bothersome to) the spectator? Because those features of the picture are not encoded, nor stored from glance to glance, any more than are the directions of sides *i* and *ii* in Figure 4c in the absence of special instruction. This may also be the case with Figures 8d and 8a; the sausages of

[7] Or, more accurately, stimulus features to which the visual system responds in the same manner as it does to stimulus features frequently encountered in the normal (nonpictorial) environment.

the one, and the digits of the other, may both be stored in terms of the same visual features.

The second answer is this: In addition to the *visual* features of the represented object, there are also *non*visual features that might be encoded, or that might offer a partial basis for encoding. In the experiment of Ryan and Schwarz, the task of the subjects was to reproduce the position of the fingers in the picture by placing their own fingers in the same position. As far as the task of reproducing the hand position is concerned, the accurate drawings, in which the fingers of rigid sections bend at the joint, may be less like what we actually *feel* that we do (muscularly) when we curl our fingers. Thus, the caricature might in fact not only be as informative as is the accurate drawing: it might even be more directly informative for the task that the subject is to perform. This, then, is a second way in which such visually disparate patterns as Figures 8d and 8a might be alike, i.e., in the bodily response that we make to them. This is not a novel idea: it rests at the heart of an old theory of Theodor Lipps', the *empathy theory*, that has recently resurfaced in somewhat different proposals by Gombrich in this volume and by Arnheim (1969), and we shall return to it shortly.

Little research (and not much more speculation) has been devoted as yet to the nature of the perceptual encoding and storage of such physical caricatures. We cannot judge, therefore, whether either or both of these answers are even partially true. The general question of how visual forms are encoded has recently begun to receive a great deal of attention, however, and the next few years may bring us relevant information. For the present, we shall see that the same issue arises again in connection with the perception of faces, whether they are pictured veridically (i.e., in perfectly accurate projection) or in caricature, and in that context we shall be able to add a little to the discussion of the issue.

5. The representation of faces: likeness and character

The world of rigid objects is full of physical regularities. Some of these are man-made (e.g., the prevalence of right angles and parallel edges), some are natural (e.g., the relationship between image-size and distance that generates linear perspective). For this

reason, it is usually easy to ask whether a picture looks distorted, because the subject has some idea of what any scene is likely to look like even if he has never seen it before: a de Chirico looks distorted, though the landscape portrayed may be completely unfamiliar. But what of *nonrigid* objects or, more specifically, what of that class of semirigid objects, *faces*, of which portraits are made?

Gombrich has recently focused attention on three problems of long standing. Two of these are posed by the fact that faces as objects differ both because persons differ in their permanent physiognomies, and because any person differs from one moment to the next as the features deform in non-rigid transformations (Gibson, 1960). How, then, can we tell whether or not a portrait is a good likeness or distorted, if we don't know the sitter? Again, how do we know whether a particular configuration of a pictured face (e.g., flared nostrils) represents the resting state of a person with that particular physiognomic endowment, or presents instead a momentary expression that is temporarily deforming the resting state (e.g., a sneer)? Obviously, in both cases there are limits to what we are prepared to accept as accurate likenesses. No one really ever looked like an El Greco or a Modigliani portrait, and surely nobody considers these paintings to be accurate projections of freakishly elongated sitters. There must also be some limits to the degree to which any picture is ambiguous about expression and endowment: surely no one takes the anguished pictures of Munch or Goya as the resting states of deviant physiognomies.

The third problem is related to the other two. Why do we seem to attribute expression to stimulus patterns which in some cases seem appropriate to elicit such responses (i.e., human faces that have their features disposed in some familiar emotional display), but which in other cases seem remote from both expression and affect? Among the cases that seem difficult to explain are those in which people seem to agree about the affective qualities of what appear to be meaningless "doodles" of line on paper (Arnheim, 1966). And if such doodles evoke affective or emotional responses in their viewers, does it not seem reasonable and economical to regard our responses to portraits as being special cases of this more general "esthetic" or "expressive" response to visual patterns? The Gestaltists' solution was that the same brain fields were produced by the "doodle," by some portrait's pattern of pigment on canvas, and

by our own affective state; but such a solution is much too general to be useful.

Partly in response to these problems, Gombrich has proposed in this volume that faces are encoded by expressive content, and that this encoding is not so much in visual as in muscular terms. This idea lay at the heart of Lipps' theory of empathy. Lipps attempted to explain esthetics in terms of the emotional or reactive response that the observer makes when he looks at even relatively simple stimuli. What makes this idea attractive is that it seems to explain the affective qualities that are so frequently attributed to even abstract and nonrepresentational art, and to explain the expressive response that we seem to make to faces that we do not know, or even to the barest caricatures.

To say that we encode our fellow humans in terms of our own muscular response may be treated as a poetic statement. However, it can also be given specific meaning, and can be used to predict which aspects of people we cannot distinguish or remember—that is, those aspects to which there is no appropriate empathic muscular response. For example, Gombrich has suggested that this is why we may not be able to describe the eye color or nose shape of someone even though we can recognize him with no hesitation at all. This suggestion might imply a very strong form of the muscle-movement encoding explanation: that *only* muscular programs are stored. But surely the strong form is neither plausible on *a priori* grounds (see also Gombrich's contribution), nor is it supported by the results of experiments on face-recognition and on expression-recognition.

The problem is really one for which psychologists have devised techniques of varying efficacy to study, attempting to determine the nature of the imagery used in some psychological process (or, more accurately, the dimensionality of storage).

In general, as we have seen, introspective discussions are not very useful, and this is as true of imagery as it is concerning perception in general. Techniques have been worked out to give us more objective measures of the kinds of information that are being encoded and stored, however, and, although these measures do not in general correlate well with subjects' own ratings about their strengths of imagery, they do have their own validity. Three general kinds of methods have been used. The first is to show that the in-

formation in question is better acquired by one sense modality than by another—say, by visual presentation rather than by auditory presentation. This technique is probably not directly applicable to the kinds of imagery that we have been discussing. The second is to show that the subject can perform tasks that are more appropriate to one sensory modality than to another. For example, if we flash an array of numbers briefly on a screen, and then ask the subject to read off the diagonal letters from his memory, it seems more likely that he can do this if his memory is visual than if his memory is verbal in its structure. Gombrich's point about our inability to remember eye color offers support for the reality of nonvisual storage, according to the logic of this second method. We might also expect, applying this logic to the strong form of the empathy theory, that after having viewed pictures of strangers, we would not be able to identify them when intermixed with pictures of other strangers if the first set of sitters wore different expressions on the second presentation than they had on the first occasion. But the fact is that we can recognize them under these conditions (Galper and Hochberg, in press), so it is not easy to maintain that we encode and store people only in terms of their expressions (whether muscularly or otherwise).

The third method for measuring "imagery" is by introducing interference of one sensory kind: if I can disrupt the observer's performance by visual distraction and not by auditory distraction, then the memorial machinery involved is in that sense more visual in its structure than auditory. Kowal and I have addressed an experiment of this kind to the hypothesis that expression is encoded in terms of kinesthesis or muscular plans. We have recently been presenting subjects with a set of pictures of a single face, in a sequence of different expressions, presented at a rate of 3 per second. The subject's task is to identify the order in which the expressions occur, by pointing to a set of still pictures of the same faces. Because the sequence occurs too rapidly to permit the subject to respond between any two presentations, he must encode and store the entire sequence and then review it in deciding the order of occurrence. Because too many different expressions are presented for the subject to retain in his immediate memory, he must look at the sequence several times before he is able to do it correctly. During one of the conditions of viewing, the subject is required to execute a

rapid series of different facial expressions himself; in this condition, both his motor plans and his kinesthetic imagery might be expected to interfere with his recognition of the sequence of faces, to the degree that expressions are encoded muscularly. Unfortunately, we have not been able to demonstrate any interference with the subject's encoding of the set of expressions, nor with his ability to report the order of their occurrence.

The evidence against the strong form of the empathy theory is by no means definitive, but it certainly does not urge us to accept the theory. The empathy theory in its strong form would have provided a set of constraints concerning our responses to faces, and a repertory within which the effects of any portrait could be explained. In order to find a new basis for explaining how we perceive and depict faces, let us re-examine the problem.

The problem is to explain the affective and expressive response that we make to faces, and to explain how we can distinguish good likeness from bad, and distinguish temporary expression from permanent facial structure. The empathy theory explains at most why we make expressive responses to visual patterns. It is, in the following ways, very much like the early empiricist explanation of depth perception: because there seemed to be no way of accounting for perceived space purely in terms of the properties of those pictorial patterns that are called depth cues, and because the perceptual attribute of *space* itself seemed so clearly characteristic of the tactual-kinesthetic memories of actions made in the tridimensional world, the spatial properties of pictures were attributed to the tactual-kinesthetic imagery they presumably aroused. The empathy theory, for very similar reasons, offers a similar explanation of face-perception. As in the case of the depth cues, neither the logic nor the evidence is compelling. When we examine the perceptual habits that the observer is likely to bring to the contemplation of portraits—habits evolved in the service of actively looking at faces to extract information that is needed to anticipate others' behavior and to guide one's own—the nature of facial representation takes on a different form.

In the case of space and object perception, we had both a general rule about how we would see a given picture (i.e., that we perceive the arrangement of objects in space that would most usually project the same stimulation to the eye as the picture does),

and one or two plausible theories to explain the origin of the rule.

What is there to represent in pictures of faces? First, of course, if we know the sitter, we might ask whether the picture is a good likeness in the sense that we can recognize the picture as his portrait. But even if the portrait is of some unknown person, it still communicates some information, just as does a landscape of some particular scene which we have never actually confronted, and we can notice whether the information is consistent. Some of the information is about the sitter's physical characteristics, such as the configuration and coloring of the head as a semirigid object, and information about gender, age, and race. Some is about the sitter's temporary state, for example, his emotional expression. And some seems to be about his character. How can all of this be represented by one and the same set of features?

When I first mentioned the problem of how it is that we can tell whether the picture represents a transient expressive deformation or a permanent physiognomic endowment, I noted that there are limits to what we might be willing to accept as physiognomic endowment—nobody will take Munch's *The Shriek*, for example, as a face in repose. This point becomes very much more important when we consider the *patterns* in which expressive deformations must normally occur.

Temporary expression and permanent endowment are not necessarily antonyms. It is not an all-or-none matter, that we see the feature *either* as temporary expression *or* as permanent endowment,[8] and part of the problem can be resolved by considering this point in some detail. In particular, the problem dwindles when we note that the features of the face are not usually viewed in isolation any more than single words are read with no context. Consider: a *momentary* widening of the mouth is clearly an expression—say, a

[8] A tempting analogy to the expression/endowment problem is offered by the depth cues illustrated in Figure 2e. In the case of the depth cues, it is true in one sense that they cannot both be flat patterns and layouts in depth: the railroad cannot both be parallel and converging. Of course, they are not both, in space: the railroad tracks themselves are parallel; it is their projection in the picture that converges. To some degree, it is true that this physical coupling of *exclusion* is mirrored in perceptual experience: at any time we tend to see either the flat pattern *or* the spatial layout. But even here, as we have seen (p. 58), we respond to both in the sense that the judgments of pictorial depth are usually a compromise.

fleeting smile. But a widened mouth can also be a much more protracted deformation, without being a truly ineradicable physiognomic feature: for example, it might be a characteristic *stance* of that person, indicating his willingness to be obliging. Of course, it might indeed be an ineradicable physiognomic endowment, having nothing to do with either a momentary emotion or with any more long term readinesses (i.e., it may offer the viewer a label by which to identify the person being portrayed, not a signal about his probable behavior).

Is it true that we cannot tell these apart? I don't think so. Physically, the facial muscles move in gross expression-like patterns in response to simple innervation (Duchenne, 1876), and the stretching and contracting of the tissues of the face, across its rigid substructure, offer redundancy to the eye of the observer. In a simple and genuine smile, for example, the mouth is stretched, *and* the eyes will be "crinkled" (Figure 9[a*i*]). In a voluntarily assumed smile, in which the actor innervates the muscles that pull his mouth wide, a much smaller set of local deformations will be involved; for example, the eyes may remain undisturbed (Figure 9[a*ii*]). In order to distinguish these two states—which have different meanings in social interaction—the viewer must learn to note the relationship between mouth and eye as a feature that distinguishes between the two states; this would seem to be a task no harder than his learning the phonemes that separate one set of speech sounds from another (e.g., *r*attle from *c*attle).[9]

The fleeting smile will engage the eyes and cheeks, as well as mouth, in a pattern of tensions that cry out their transience and imminent resolution. Such a portrait will seem to catch a frozen moment, and may tell us little about the sitter save that he or she is capable of that human action. One can, of course, use the fleeting expression to identify the picture itself, or to identify the moment, but it would clearly not do to identify the person: it signals its own change and disappearance.

In the case of a prolonged or habitual smile, on the other hand,

[9] Note that it is the overall inherent [and inherited] simplicity of innervation of some facial expressions that makes them difficult to mimic. This is what makes it easy to produce stances that will *not* be confused with spontaneous expressions, and makes it easy to detect insincerity—an ability that it should be very profitable to investigate.

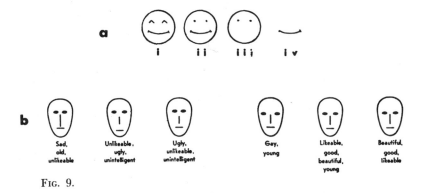

a

i ii iii iv

b

Sad, Unlikeable, Ugly, Gay, Likeable, Beautiful,
old, ugly, unlikeable, young good, good,
unlikeable unintelligent unintelligent beautiful, likeable
 young

FIG. 9.

the tensions must be minimal (e.g., the eyes may be attentive or grave, but not crinkled up), and we see a state that may last for some time. Note that a picture, unless otherwise marked so as to indicate its momentary and uncharacteristic nature, will probably be taken as being the typical state of the object or scene depicted, inasmuch as it would be a statistical improbability that the picture would have been taken at some uncharacteristic moment. (This is similar to the reason why *good continuation* is such a powerful organizational determinant; see (p. 72.) The picture then allows us to predict (perhaps wrongly) the nature of the person's response-readinesses. Or it shows the face with several local deformations, which we can identify as being *some* stance, but we may not know what the behavioral consequences are (as in la Giaconda). In both cases, the portrait has more-or-less obvious "character." That character will also serve to identify the sitter, as well as to help predict his social responses, to the degree that the pattern of features is clearly an habitual or non-momentary expression. (Many habitual expressions probably have their own signs that identify them as such.) Thus the apparent paradox of how we can judge whether or not the portrait of someone we have never seen has captured his character is resolved; the answer to whether we choose to regard a given feature as being an expressive deformation, or a relatively permanent characteristic, may be "both."

Before we turn to the last case, the deviant physiognomic feature (as opposed to the momentary expression or the habitual

stance), there are two questions that we should consider with respect to the stimuli for "character": (a) *can* we respond to such "higher-order variables" (Gibson, 1950; 1960; 1966) that involve not one, but several different features (e.g., widened lips, slightly indented mouth corners, noncrinkled eyes) with a single unitary response (e.g., "calm amiability")?; and, if so, (b) *why* do we do so?

With respect to whether we can so respond: The answer seems to be a qualified "yes," with the qualification being that it may take somewhat longer to do so than it does for single features. Consider the features that go into identifying the age of a sitter whom we have never seen. We can tell whether his hair is prematurely gray, or whether his face is prematurely wrinkled, or whether he simply has sunken jaws, etc. Although not one of these cues, taken alone, defines the sitter's age, yet we can make quite finely graded estimates of how old he is, and recognize him as the same sitter that we have seen in another portrait. The problem, as Gombrich here recognizes, is very close to that of how expression is perceived, and the solution seems to me to be the same: we have learned the local and higher-order features of age that are common to all men (and unadorned women), and there are features of physiognomic endowment that do not normally vary much either from one age group to another, or from one expressive deformation to another.

There is a qualification that should be appended: the distinction between "higher-order" and "local" features that I am making here is based on whether a given stimulus feature can be detected during a single glance, in which case it is a local feature (i.e., it may be a compact pattern that falls entirely within the field of foveal vision in a single glance, or a pattern that is sufficiently gross to be recognizable even when much of it falls in peripheral vision); or conversely, it may require several glances to sample the characteristic pattern of stimulation (e.g., mouth corners, cheeks, and eyelids), and as a higher-order feature it will therefore take longer to apprehend (at least 250 msec per glance) and will require facilities for encoding, anticipating, and storing the widespread pattern between glances (see p. 68).

The next question to consider is *why* we respond to such cues about the temporary, habitual, and permanent characteristics of the sitter.

The momentary emotional expressions (and some of the more

protracted stances, such as *vigilance*) have been with the species a long time. They have probably served as signals that, when manifested by one actor, demanded attention and responses (of vigilance, attack, flight, sexual approach, etc.) from all observers, long before our present facile human speech developed. Given the neural mechanisms for emitting these facial (and bodily) behaviors as signals to the other members of one's group, it seems very likely that *partial* gestures are soon learned to help us in less emotional communication. Understanding speech (like reading) probably places very high demands on one's anticipations and expectancies, and the speaker's stances will help reduce the listener's uncertainty about a verbal message, or about the general nature of the speaker's intentions (e.g., truculent, attentive, amiable, deferential). Such distinctive features of the social interaction should be as subject to learning as are the phonemes by which the listener learns to distinguish one word from the next. And this should be true not only about anticipating speech messages per se, but in steering the complex but finely tuned "interaction rituals" by which social contact is shaped and maintained (Goffman, 1967).

Bear in mind both the fact that it takes time (and several glances) to survey the higher-order expressions, and the argument just made that facial expressions serve as signals to guide social interaction (and active listening) by shaping the participants' anticipations. We should then expect that, in general, even a single local part of a higher-order expression will come to serve as a signal, and will have *some* expressive effect on the viewer: for example, a widened mouth, even without confirmation from the eyes, will be a tentative basis for assuming a smile (Figure 9a[*ii*]). Local cues (that is, departures from the norm of what features should look like in their resting state) are like initial syllables in words: they may be disconfirmed or confirmed by subsequent events, but meanwhile they probably affect the observer's expectations. This brings us to the final case, the deviant physiognomic feature.

The person with the wide mouth has one of the local features of a smile—but it is only one feature, and all of the other confirming cues will most likely be missing (i.e., it is improbable that he will also just happen to be so endowed that his eyes, in resting state, are "crinkled up" as they would be in a genuine smile). If the rest of the face is merely neutral (Figure 9a[*ii*]) and does not actually

disconfirm the smile, the face will probably be encoded as having a smiling stance. After long acquaintance with the sitter, I should be able to identify those specific and idiosyncratic signs that would enable me to disconfirm the stance that is (spuriously) signaled by his wide mouth. But otherwise, the wide mouth should affect my expectations about him. And, of course, a person's physiognomic endowments *do* affect our judgments of his expression, even though (or especially because) we cannot tell *precisely* what his resting state is. There is a great deal of experimental evidence supporting the obvious fact that perfect strangers, even with their features "in repose" (if features are ever fully in repose while the subject lives), appear to have discernible character traits. Thus subjects show a great deal of consistency in their judgments when they are asked to evaluate, from photographs, the characters or personalities of persons whom they have never seen before (see Secord, 1958), and when they are asked to decide what a person intended to convey by an ambiguous statement that was included in a briefly described social situation (Hochberg and Galper. In preparation.)

My argument here is very close to those I have proposed earlier to explain the efficacy of outline drawings and of the Gestalt "laws of organization" (ie., that lines serve as cues about the object's edges that we should expect to find when we sample the visual field), and to explain the reading process (i.e., that the letters and word-forms that we glimpse in one fixation serve as cues about those that we can expect to find when we sample the text further on). My present proposal is that a person's expressive features serve to signal what that person will do next (Hochberg, 1964), thereby serving primarily to reduce the observer's uncertainty about what the other person intends to say or do. If a local feature has the shape it would have in one of the common paralinguistic gestures, and if it is not disconfirmed by other features, it will therefore evoke an "expressive expectation" on the part of the observer. Features that do not have any place in an expressional deformation (e.g., a high forehead) may also have affective connotations for two reasons: (1) they may present a relationship that is also presented by some expressional deformation (e.g., raised eyebrows); or (2) they may deviate from the norm in the direction of some well-established model that carries its own set of expectations with it (e.g., being babyish).

Thus we can account for the fact that faces, even in repose, have expressive effects on the viewer, and we can do so without necessarily calling on the empathy theory. Furthermore, even isolated lines will usually share some feature of their shape with some expressive stance, as long as the viewer approaches them as expressive features. This is especially so when there is no way to check any other features in the (nonexistent) face (Figure 9a[*iv*]). This is then one of the powers of the caricature: by eliminating disconfirming features, it can present the sitter's wide mouth, which is characteristic and which everyone recognizes, as an expressive stance instead of the physiognomic endowment that it may in actuality be.

This explanation assumes that the lines and patterns of a caricature have the effects they do because they are encoded in the same way as the expressive gestures to which we must normally attend in dealing with people. Thus, the symbols of cartoon iconography are not arbitrary in the sense that they have to be learned by experience with the artist's repertory of expressive elements. Although we have no research to the point, it does seem that at least some minimum content of the comic strip can be comprehended without specific instruction: even untutored children recognize (and revel in) cartoons and comic strips.[10] In most cases the cartoon is "wrong" in the sense that it does not produce the same sheaf of light rays to the eye that the object does. What features of Mickey Mouse can be made to coincide with those of a real mouse? or with those of a human? Nevertheless, the way in which the physiognomy and expression of Mickey Mouse is encoded and stored *must be identical in some fashion* to the way in which those of a mouse—and a human—are stored. Inasmuch as it is very likely that these similarities are not merely the result of having been taught to apply the same verbal names to both sets of patterns (i.e, both to the features of caricatures and to the features of the objects that they represent), what we learn about caricature will help us understand how faces themselves are perceived.

[10] We don't know how much (and what kind of) pictorial education underlies the ability to recognize cartoons, but it is clearly not of the paired-associates variety (e.g., man = l'homme) that is involved when adults learn new languages; moreover, as we have seen, some features of normal perception must also be tapped by cartoon recognition.

One way we might discover the features of caricature is by exploiting what Gombrich has called "Toepffer's law": making systematic variations in drawings of faces and discovering their effects on the viewer. Some work has been done on this, mostly by using very simplified drawings such as those of Figure 9b (Brunswik and Reiter, 1937; Brooks and Hochberg, 1960). Subjects seem to agree about the relative mood, age, beauty, intelligence, etc., of such pictures; and as aspects of the stimulus pattern are changed, subjects' judgments of entire sets (or "packets") of traits follow suit: pictures in which the mouth was high were judged as being gay, young, unitelligent, and unenergetic (Brunswik and Reiter, 1937; Samuels, 1939). There is some reason to doubt whether such simple drawings can really be treated as a set of caricatures of faces, and whether the results of such inquiry can be applied to more complex and veridical pictures and photographs (Samuels, 1939), but that is a matter for empirical inquiry in any case, and it seems abundantly clear that fruitful research is possible with such tools.

I know of no research addressed to the relative comprehensibility of caricatures of people versus veridical portraits and photographs, but it seems very likely that recognition would be faster for good caricatures than for nondistorted pictures. In addition to the factors adduced in connection with the Ryan and Schwarz experiment, there are three other reasons why caricatures may be more effective than photographs, reasons specific to the caricatures of people.

As a first point, we should note that caricatures make possible a more compact visual vocabulary. That is, caricatures use a relatively small number of features by which to represent a much larger set of faces. (Remember that we are using the word "features" in a general sense that applies to text, to speech, and to objects, and not solely to the gross anatomical parts of the face that are frequently intended by that term.) There are at least three reasons why a relatively small set of features will suffice:

1. Although the anatomical parts of human physiognomies may differ from each other in very many ways, and in very many gradations, some of these differences are effectively imperceptible.

2. More important than the fact that some of the ways in which faces differ from each other are imperceptible is the fact that *we do not need to notice all of the ways in which faces differ from each other in order to tell them apart.* For any set of faces, each of

which we may wish to be able to identify rapidly and with assurance, the set of features that we must have if we are to identify any individual face can probably be considerably smaller in number than the set of features that actually varies from one person to the next. That is, the differences between people in any group are probably *redundant* in the technical sense of that term (Garner, 1962). Thus the observer need only identify the population of faces being used (e.g., heads of state, stage celebrities, the cast of characters of a particular comic strip), and for this task a small visual vocabulary will suffice. This implies what Garner and his colleagues have demonstrated to be true for the recognition and storage of abstract patterns (1963, 1966): that the qualities (and identifiability) of a particular stimulus depend on the total set of stimuli to which the viewer attributes it. (I believe that the same applies to what is usually meant by "esthetic value"; but that is another story for another time.) In illustration of this point: an eyepatch can identify Moshe Dayan only in the context of politicians; in children's tales, the eyepatch might signify Old Pew; and in a company of pirates, it identifies no one.

3. Finally, we have seen that inconsistencies are tolerated, in pictures, that simply would not be possible in physical reality, and this means that the caricaturist is free to choose features so that each is close to its canonical form (i.e., so that each feature is approximately in the form in which it is remembered), and so that the pattern formed by the arrangement of the features is also close to *its* canonical form, even though no face could ever be seen in this way from a single viewpoint.

These factors should all contribute to making the caricature more readily comprehensible than the veridical picture of the perfect photograph that stimulates the eye in exactly the same way as does the person being portrayed. If, in addition, an "accidental" feature of physiognomic endowment that is so characteristic of the person as to identify him can be presented in a way that is also characteristic of some expressive stance (which, in turn, is germane to the context in which we must think of that person—see Gombrich, 1956, p. 344), it might well be that the caricature can change our attitudes toward that person. Research on the nature of caricature may thus be as central to the study of how we perceive and think about people as research on Leonardo's depth cues was central to the study of space perception.

6. Summary

In the simplest sense, an object may be "represented" by replacing it with any other object that projects the same pattern of light to the viewer's eye. The problems here are predominantly geometrical ones, and Leonardo's prescriptions were to this point. But why we see pictures as represented scenes, rather than as patterned canvases, and why we not only tolerate but require major "distortions" or departures from projective fidelity, in scenes and portraits alike—these are predominantly psychological problems, often taken as demonstrating the symbolic and arbitrary nature of "pictorial language." Even our perception of a static picture, however, requires that successive glances be integrated over time (just as when we read text or watch motion picture montages) and consists therefore mostly of memories and expectations that reflect a much more rapid and intimate interaction with the world, and with its signals about what the next glance may bring, than is connoted by the concept of "symbols." The fundamental features of pictorial representation are probably learned by commerce with the world itself (where learned at all, and not innate), not established by arbitrary convention that the artist is free to devise at will.

Arnheim, R. *Toward A Psychology of Art*. Los Angeles: University of California Press, 1966.

―――. *Visual Thinking*. Los Angeles: University of California Press, 1969.

Attneave, F., and Frost, R. "The Discrimination of Perceived Tridimensional Orientation by Minimum Criteria." *Perception and Psychophysics* 6(1969): 391–96.

Brentano, F. *Psychologie von Empirischen Standpunkt*. Leipzig: Felix Meiner, 1924–25.

Brooks, V. An Exploratory Comparison of Some Measures of Attention. Masters Thesis, Cornell University. 1961.

Brooks, V. and Hochberg, J. "A Psychological Study of 'Cuteness'." *Perceptual and Motor Skills* 11(1960): 205.

Bruner, J. S. "On Perceptual Readiness." *Psychological Review* 64(1957): 123–52.

Brunswik, E. *Perception and the Representative Design of Psychological Experiments*. Los Angeles: University of California Press, 1956.

Brunswik, E., and Reiter, L. "Eindrucks Charaktere Schematisierter Gesichter." *Zeitschrift f. Psychol.* 142(1937): 67–134.

Buswell, G. T. *How People Look at Pictures.* Chicago: University of Chicago Press, 1935.

Duchenne, G. *Mécanisme de las Physionomie Humaine.* Paris: Baillière et Fils, 1876.

Epstein, W., Park, J., and Casey, A. "The Current Status of the Size-distance Hypothesis." *Psychological Bulletin* 58(1961): 491–514.

Escher, M. *The Graphic Works of M. C. Escher.* New York: Duell, Sloan and Pearce, 1961.

Galper, R. E., and Hochberg, J. "Recognition memory for photographs of faces." *American Journal of Psychology.* In press.

Garner, W. R. *Uncertainty and structure as psychological concepts.* New York: Wiley, 1962.

———. To perceive is to know. *American Psychology* 21(1966): 11–18.

Garner, W. R. and Clement, D. E. "Goodness of pattern and pattern uncertainty." *J. verb. Learn. verb. Behav.* 2(1963): 446–52.

Gibson, E. J. *Principles of Perceptual Learning and Development.* New York: Appleton-Century-Crofts, 1969.

Gibson, E. J.; Osser, H.; Schiff, W.; and Smith, J. *Cooperative Research Project No. 639.* U. S. Office of Education.

Gibson, J. "A Theory of Pictorial Perception." *Audio-visual Communications Review* 1(1954): 3–23.

———. *The Perception of the Visual World.* New York: Houghton Mifflin Co., 1950.

———. "Pictures, Perspective and Perception." *Daedalus* 89(Winter 1960): 216–14.

———. *The Senses Considered as Perceptual Systems.* Boston: Houghton Mifflin Co., 1966.

Goffman, E. *Interaction Ritual.* Garden City: Anchor, 1967.

Gombrich, E. H. *Art and Illusion.* Princeton: Princeton University Press, 1956.

———. "The 'What' and the 'How': Perspective Representation and the Phenomenal World." In *Logic and Art, Essays in Honor of Nelson Goodman,* ed. Richard Rudner and Israel Scheffler. Indianapolis and New York: 1972. Pp. 129–49.

Goodman, N. *Languages of Art: An approach to a theory of symbols.* Indianapolis, Ind.: The Bobbs-Merrill Co., Inc., 1968.

Hebb, D. *The Organization of Behavior.* New York: Wiley, 1949.

Hochberg, J. "Attention, Organization and Consciousness." In *Attention: Contemporary Theory and Analysis,* ed. D. I. Mostofsky. New York: Appleton-Century-Crofts, 1970.

———. *Perception.* New York: Prentice-Hall, 1964.

———. "In the Mind's Eye." in *Contemporary Theory and Research* in

Visual Perception, ed. R. H. Haber. New York: Holt, Rinehart and Winston, 1968.

———. "Nativism and Empiricism in Perception." In *Psychology in the Making*, ed. L. Postman. New York: Knopf, 1962.

———. "The Psychophysics of Pictorial Perception." *Audio-Visual Communications Review*, 10–5 (1962).

Hochberg, J., and Brooks, V. "The Psychophysics of Form: Reversible-perspective Drawings of Spatial Objects." *American Journal of Psychology* 73(1960): 337–54.

———. Pictorial recognition as an unlearned ability:. A study of one child's performance. *American Journal of Psychology* 75(1962): 624–28.

Hochberg, J. and Galper, R. E. *Attributed intent as a function of physiognomy*. In preparation.

Lashley, K. S. "The problem of serial order in behavior." In *Cerebral Mechanisms in Behavior, The Hixon Symposium*, ed. Lloyd A. Jeffress. New York: Wiley, 1951.

Metzger, W. *Gesetze des Sehens*. Frankfurt: Waldemar Kramer, 1953.

Miller, G. A.; Galanter, E.; Pribram, K. *Plans and the Structure of Behavior*. New York: Henry Holt and Company, 1960.

Pirenne, M. H. *Optics. Painting and Photography*. London: Cambridge University Press, 1970.

Pollack, I., and Spencer. "Subjective Pictorial Information and Visual Search." *Perception and Psychophysics*, 3 (1-B) (1968): 41–44.

Riggs, L. A. "Visual Acuity." In *Vision and Visual Perception*, ed. C. H. Graham. New York: Wiley & Sons, 1965.

Ryan T., and Schwartz, C. "Speed of Perception as a Function of Mode of Representation." *American Journal of Psychology* 69(1956): 60–69.

Samuels, F. *Judgement of Faces, Character and Personality* 8(1939): 18–27.

Secord, P. F. Facial features and inference processes in interpersonal perception. In *Person Perception and Interpersonal Behavior*, ed. R. Tagiuri and L. Petrullo. California: Stanford University Press, 1958.

Taylor, J. *Design and Expression In The Visual Arts*. New York: Dover, 1964.

Tolman, E. C. *Purposive Behavior In Animals and Men*. New York: Century, 1932.

MAX BLACK

how do
pictures
represent?

Some questions. There on the wall is a painting: it plainly shows some racehorse or other, with trees that might be beeches in the background and a stableboy doing something or other with a pail in the foreground. That the picture shows all these things, that all these things and more can be seen in the painting, is beyond doubt. But what makes that painting a picture of a horse, trees, and a man? More generally, what makes any "naturalistic" painting or photograph a representation of its subject? And how, if at all, does the situation change when we pass to such "conventional" representations as maps, diagrams, or models? To what extent do "convention" or "interpretation" help to constitute the relation between any representation and its subject?

These are the sorts of questions that I would like to consider (though not all of them in this essay), more in the hope of clarifying the questions themselves than in the hope of finding acceptable answers. For the main difficulties in the inquiry arise from lack of clarity in such words as 'representation', 'subject', and 'convention'

that spring naturally to mind and cannot be avoided without tiresome paraphrase.

Preliminary qualms. Are questions as imprecise and confused as these worth raising? Or are they perhaps merely symptoms of the philosopher's itch to puzzle himself about what seems unproblematic to everybody else? Well, the itch is infectious, even to laymen. The disconcerting thing, as we shall soon see, is that the most plausible answers that suggest themselves are open to grave and perhaps fatal objections. Yet even partial answers have consequences for such varied topics as perception, cognition, the structure of symbol systems, the relations between thought and feeling, and the aesthetics of the visual arts. To understand the reasons for the excessive discord produced by questions about representation would be sufficient reward for what threatens to be an arduous, even a somewhat tiresome, investigation.

Some working definitions. When a painting—or some other visual representation, such as a photograph—is a painting *of* something, *S*, I shall say that *P depicts S*; alternatively, that *P* stands in a *depicting relation* to *S*. There is, however, room for misunderstanding here.

Suppose *P* shows Washington crossing the Delaware. Then *P* is related to Washington's actual crossing of the Delaware, in 1776, in such a way that it can be judged to be a more or less faithful, or a more or less inaccurate, painting of that historical episode. I do not want to count that historical event as a special case of the subject, *S*, introduced in the last paragraph. Consider for contrast the case of another painting that shows Hitler crossing the Hudson in 1950: here there is no actual event to serve as a control of the painting's fidelity; yet we still want to say that the painting has a "subject" that is depicted by it.

Let us call Washington's crossing of the Delaware the *original scene* to which the painting refers; and for the sake of precision let us say that the painting does not merely depict that scene but rather *portrays* it. Then the painting of Hitler's imaginary river crossing will have no original scene to portray; but it may be said to *display* a certain subject. Thus portraying and displaying will count as special cases of depicting.

The displayed subject might be conceived of as the *content* of

the visual representation.[1] I shall normally be concerned with depicting in the special sense of "displaying," and correspondingly with that "subject" of a painting that is its "content," not its "original scene." Where the context is suitable and no other indication is given, the reader may take "depict" and "display" henceforward as synonymous.

It should be borne in mind that I am not initially committed to there always being an irreducible difference between "subject" and "original scene." More importantly still, I am not committed—as talk about the relation between P and S might misleadingly suggest—to the existence of the "subject" S as an independent entity in its own right. It is compatible with everything that has so far been said that *displaying-S* might turn out to be a unitary predicate, carrying no implication as to the existence or non-existence of S. Thus, the occurrence of S in 'depicting-S' might be "intensional," not "extensional."

In search of criteria. An ambitious investigator of our syllabus of questions might hope to discover an analytical definition of *displaying* or *displaying-S*, that is to say, some formula having the structure:

$$P \text{ displays } S \text{ if and only if } R,$$

where 'R' is to be replaced by some expression that is more detailed and more illuminating (whatever we take that to mean) than the unelaborated word, "displays." R, then, will constitute the necessary and sufficient condition for P to "display" S.

It is probably unrealistic to expect that we can find a set of necessary and sufficient conditions conforming to this pattern. But we need not be committed to this goal, for it would already be somewhat illuminating if we could only isolate some necessary conditions. A still more modest goal, difficult enough to attain, would be to exhibit some *criteria* for the application of expressions of the form 'displays S', that is to say conditions that count, in virtue of the relevant meaning of 'displays' and nothing else, for or against

[1] There is an obvious analogy here with the sense/reference distinction connected with verbal descriptions. In the case of such a description, the "original scene," if any, corresponds to the entity or event identified by the description. The displayed subject of the painting is analogous to the description's sense or meaning, which attaches to it whether or not it identifies any actual entity or event.

its applicability to given instances. Such criteria need not be invariably or universally relevant, always in point whenever it makes sense to speak of something showing or displaying something else: the criteria of application might vary from case to case in some systematic and describable fashion. The goal would then be partial but explicit insight into the pattern of uses of 'depicts' and its paronyms, rather than a formal definition.[2] Nevertheless, although this is the program, I shall first adopt the plan of examining seriatim a number of plausibly necessary conditions for "displaying." Only after we have become convinced that none of these candidates separately—and not even all of them jointly—can serve as an analysis of our quaesitum shall I proceed to argue for a more flexible type of answer.

Somebody influenced by Wittgenstein's parallel investigations of fundamental concepts might regard our enterprise, even thus circumscribed, as reprehensibly quixotic, expecting to find the "patterns of use" too ravelled for reduction to any formula. Such pessimism might be countered by recalling that "creative power" of language, as important as it is truistic, in virtue of which we can understand what is meant by something of the form "P is a painting of S" even when asserted of some painting in a new, unfamiliar or recondite style. That we think we understand what is said in such contexts argues powerfully for the existence of an underlying pattern of application waiting to be exhibited. Even if this were an illusion, it would be one in need of explanation.

A principled objection. A search for analytical criteria of application for 'displaying' naturally recalls the many abortive efforts that have been made to provide partial or complete analyses of verbal meaning. Indeed, there may be more than analogy here. Of a verbal text we can properly say, echoing some of our earlier formulations, that it is a description or representation *of* some scene, situation, or state of affairs, presented via the "content" of the text and possibly corresponding to some verifying fact (the analogue of our "original scene"). Thus questions arise that seem to parallel those about pictorial representation which I have em-

[2] Cf. the corresponding analytical task for "the concept of cause," where, in my opinion, the best to be hoped for is a similar mapping of variations of sense, based upon an exhibition of the relevant criteria of application underlying such variation.

phasized. Some writers, indeed, try to assimilate the latter to the former, drawing their explanatory and analytical concepts from the domain of verbal semantics.

Now are there any good reasons to think that a search for a conceptual map of verbal meaning is bound to be abortive? The late John Austin seems to have thought so (cf. Austin, 1961), for reasons that do not seem to have been discussed in print.

Austin contrasts a search for the meaning of a particular word or expression with what he takes to be the illegitimate search for meaning in general. He reminds us that the first kind of question is answered when we can "explain the syntactics" and "demonstrate the semantics" of the word or expression in question. That is to say, when we can state the grammatical constraints on the expression and its ostensive or quasi-ostensive links with non-verbal objects and situations (where this is appropriate). But then Austin objects that the supposedly more general question "What is the meaning of a word-in-general?" is a spurious one. "I can only answer a question of the form 'What is the meaning of "x"?' if 'x' is some particular word you are asking about. This supposed *general* question is really just a spurious question of a type which commonly arises in philosophy. We may call it the fallacy of asking about 'Nothing-in-particular' which is a practice decried by the plain man, but by the philosopher called 'generalizing' and regarded with some complacency" (p. 25).

If Austin were right, a similar absurdity should infect our main question about the meaning of "*P* is a painting of *S*," since we are not raising it about any given painting, but about no painting in particular. Austin's idea, so far as I have been able to follow it, seems to have been that the rejected general question about the meaning of a word in general is apt to be taken as a search for a single meaning, *common to all words*. And similarly, if he were right, our own problem would be the ridiculous one of trying to find a single common subject for all paintings. So conceived, the quest would indeed be spurious, not to say preposterously confused.

It is interesting to notice, however, that immediately after rejecting the "general question" about meaning, Austin admits as legitimate the general question "What is the 'square root' of a number?"—of any number, not any particular number. But if that is a legitimate way of looking for a definition of 'square root', why

should we not regard the "general question" about meaning, with equal justice, as a legitimate way of looking for a definition—or at least something relevant to the definition—of 'meaning'?

Austin's reason for distinguishing the two cases apparently arises from his conviction (which I share) that " 'the meaning of p' is not a definite description of any entity" (p. 26), whereas 'square root of n' is (when the variable is replaced by a constant). I cannot see why this should make a relevant difference. It would indeed be naive to think of the search for an analysis of 'displaying S' as presupposing the existence of some entity indifferently displayed by all paintings. But this concession need not imply the rejection of any search for general criteria as spurious. Oddly enough, after Austin's characteristically energetic attack upon the "general" enterprise of delineating the concept of meaning, he proceeds to assign that same task an acceptable sense by taking it to be an attempt to answer the question "What-is-the-meaning-of (the phrase) 'the-meaning-of (the word) "x" '?". The corresponding question for us might be "What is the meaning of (the phrase) 'displaying-S'?". We can then proceed, as Austin recommends, to investigate the "syntactics and semantics" of that expression, without commitment to the existence of dubious entities and without nagging anxieties about the supposed spuriousness of the enterprise. It may prove impossible to reach our goal, but that remains to be seen.

How does a photograph depict? I shall now consider for a while the form taken by our basic question about the nature of depiction, when applied to the special case of photographs. For if any pictures stand in some "natural" relation to their displayed or portrayed subjects, unretouched photographs ought to provide prime examples. There, surely, we ought to be able to discern whatever complexities underlie the notion of faithful "copying" at its least problematic. Since photographs also provide minimal scope for the "expressive" intentions of their producers, we shall be able to bracket considerations connected with the expressive aspects of visual art (whose crucial importance in other contexts is, of course, undeniable).

What, then, is it about a given photograph, P, that entitles us to say that it is a photograph of a certain S? Here is a picture postcard labelled "Westminster Abbey." What justifies us and enables us to say that it is a photograph *of* a certain famous building in

London—or, at least, for somebody who has never heard of the Abbey, of a certain building having certain presented properties (twin towers, an ornamented front, and so on)?[3]

Appeal to a causal history. The first answer to be considered seeks to analyze the imputed depicting relation in terms of a certain causal sequence between some "original scene" (what the camera was originally pointed at) and the photograph, considered as an end-term in that sequence. The photograph, P, that is to say a certain piece of shiny paper, showing a distribution of light and dark patches, resulted—so the story goes—from a camera's being pointed upon a certain occasion at *Westminster Abbey*, thus allowing a certain sheaf of light rays to fall upon a photo-sensitive film, which was subsequently subjected to various chemical and optical processes ("developing" and "printing"), so that at last *this* object—the photograph in our hands—resulted. In short, the aetiology of the representing vehicle, P, is supposed to furnish our desired answer.

Reducing the causal narrative to essentials, we get the following account: P portrays S, in virtue of the fact that S was a salient cause-factor in the production of P; and P displays S', in virtue of the fact that S satisfied the description that might be inserted for "S'" (a building having towers, etc.). On this view, P might be regarded as a *trace*[4] of S and the interpretation of P is a matter of inference to an earlier term in a certain causal sequence.

An immediate obstacle to the acceptability of this account is the difficulty in specifying the "portrayed subject," S, and that abstract of it which is the "displayed subject," S'. For an inference from P to the circumstances of its original generation will yield any number of facts about the camera's focal aperture, its distance from the nearest prominent physical object, perhaps the exposure time, and so on, which we should not want to count as part of the "subject" in either sense of that word. There must be some way of

[3] I am here deliberately ignoring, for the time being, the distinction previously introduced between the displayed and the portrayed subject. For to make this distinction at once might interfere with the plausibility of the first answer now to be considered.

[4] "It will be helpful if we look at images as traces, natural or artificial ones. After all, a photograph is nothing but such a natural trace, a series of tracks left ... on the emulsion of the film by the variously distributed lightwaves which produced chemical changes made visible and permanent through further chemical operations" (Gombrich 1969, p. 36).

selecting, out of the set of possible inferences from the physical character of P, some smaller set of facts which are to count as relevant to P's content.

An associated difficulty lurks behind the lazy formula that identifies S', the displayed subject (and our main interest), with a certain "abstract" of the properties of S. At the moment the photograph was taken, the Abbey must have had any number of properties that might be inferred from the photograph, though irrelevant to that photograph's content. (If the picture showed the doors open, one might correctly infer that visitors were to be found in the Abbey's interior on that day.) Even to limit S' to a specification of visual properties will not serve: somebody might be able to infer correctly all manner of conclusions about the Abbey's visual appearance (e.g., that it looks as if it were leaning on the spectator) without such items being *shown* in the picture.

Some writers have thought that such objections might be overcome by considering the "information" about the Abbey's visual appearance at a certain moment, supposedly embodied in the final print. Such "information" is conceived to have been contained in the sheaf of light-rays originally impinging upon the camera's lens and to have remained "invariant" through all the subsequent chemical transformations. What makes anything, A, a "trace" of something else, B, is just that A in this way presents information about B. Examination of the immanent "information" contained in P would thus presumably allow us to distinguish between warranted and unwarranted inference to P's aetiology and so to eliminate the uncertainties about the displayed and the portrayed subjects. I shall subject this conception to criticism below. But we might as well notice another difficulty at once.

Suppose the causal history of a certain photograph to be as outlined above (pointing at the Abbey, chemical changes in the photo-sensitive emulsion, and so on) while the final outcome consisted of nothing better than a uniform grey blur. Should we then, in order to be consistent, have to maintain that we did indeed end with a photograph of Westminster Abbey, though a highly uninformative one?[5] Notice that the Abbey might indeed present the

[5] Some members of my audience at the lecture on which this essay is based were willing to take this view, insisting that the aetiology had over-riding importance,

appearance of a grey blur if seen through eyelids almost closed: perhaps the "uninformative" photograph should be regarded as yielding only an *unusual view* of the Abbey? But this is surely too paradoxical to be acceptable.

The moral of this counter-example is that reliance upon the photograph's history of production is insufficient to certify it as having the Abbey, or an abbey, as its subject. No genetic narrative of the photograph's provenance, no matter how detailed and accurate, can logically guarantee that photograph's fidelity. (Of course, if the "accuracy" of the causal account is to be determined by some other kind of test—say "invariance of information," construed as involving no reference to any causal history—the causal account is already shown to be insufficient.)

The causal account I have imagined, now seen to be insufficient as an analysis of the photograph's content, can also be shown not to be necessary either.

Suppose someone invents a new kind of photo-sensitive paper, a sheet of which, upon being "exposed" by simply being held up in front of the Abbey, immediately acquires and preserves the appearance of a conventional photograph. Would we then refuse to call it a photograph of the Abbey? We might perhaps not want to call it a *photograph*, but no matter: it would still surely count as a visual representation of the Abbey.

A defender of the causal approach might retort that the extraordinary paper I have imagined was at least printed at the Abbey, so that the "essentials" of the imputed causal history were preserved. After all, he might add, we are not even normally interested in the details of the particular chemical and physical processes used in producing the final print. Well, so long as we are indulging in fantasy, let us suppose that the extraordinary imprinting effect was producible only by pointing the sensitive paper *away* from the Abbey, while the result was still indistinguishable from the conventional photograph: would that disqualify the product as a visual representation and, for all we know, a highly faithful one?

Some philosophers might reply that if causal laws were violated

no matter how disappointing the resulting "trace." This illustrates the grip that the causal model can have—to the point of its being accepted in the teeth of the most absurd consequences.

in these or other extraordinary ways, we "should not know what to think or say." But that seems a lazy way with a conceptual difficulty. Perhaps a single odd example of the kind I have imagined would leave us hopelessly puzzled. But if the phenomenon were regularly reproducible by a standard procedure, I suppose we should be justified in saying that we had simply discovered some new, albeit puzzling, way of producing representations or "likenesses" of the Abbey and other objects. It would be easy to concoct any number of other counter-examples in which end-products indistinguishable from conventional photographs might arise from radically unorthodox procedures.

One might be inclined to draw the moral that the causal histories of photographs—or their fantastic surrogates—are wholly irrelevant to our warranted judgments that they are depictions of the Abbey. But to reject the causal view so drastically may be too hasty. Suppose we found some natural object that "looked like" a certain subject—say, a rock formation that from a certain standpoint looked for all the world like Napoleon: should we then say that the rock formation must be a representation of Napoleon? (Or suppose, for that matter, that objects, looking for all the world like photographs, simply rained down from the sky at certain times.) Surely not. It looks as if the background of a certain aetiology is at least relevant (without being either a necessary or a sufficient condition) in ways that need to be made clearer before we are through.

An obvious counter might be that in the case of the imagined sensitive paper, and in the other examples that we might be inclined to concoct, something must be deliberately *positioned* in order to create, if all goes well, a representation of the subject in question. To be sure, this would exclude the supposed counter-instances of the natural objects, or the objects of unknown provenance that were simply indistinguishable from conventional photographs. But in this imagined objection, there is plainly an appeal to a very different sort of criterion, the *intention* that launched the causal process. This deserves separate discussion. Let us first, however, look more closely at the suggestion that the notion of "information" provides the clue for which we are searching.

Appeal to embodied "information." As I have already said, our puzzle about the blurred photograph would be regarded by some writers as explainable by the "absence of sufficient information" in

the final print. More generally, the concept of "information," supposedly suggested by the notion thus designated in the mathematical theory of communication, is held to be useful in resolving the conceptual difficulties that we are trying to clarify.[6]

The current vogue for speaking about "information" contained in representations—and indeed, for bringing that notion into almost any kind of discussion—is certainly influenced by the supposed successes of the notion of "information" that is prominent in the sophisticated mathematical theories usually associated with the name of Shannon.[7] Yet it is easy to show that the two senses of "information" involved have very little to do with one another.

Let us recapitulate briefly what "information" means in the context of the mathematical theory. The first point to be made is that in that theory we are dealing with a *statistical* notion—let us call it "selective information"[8] henceforward to avoid confusion. The typical situation to which the mathematical theory applies is one in which some determinate stock of possible "messages," which may be conceived as alternative characters in an "alphabet" (letters, digits, or pulses of energy) *to which no meaning is necessarily attached,* are encoded into "signals" for transmission along a "communication channel" and ultimate reception, decoding and accurate reproduction of the original "message." Thus individual letters of the English alphabet are converted into electrical pulses along a telegraph wire, in order to produce at the other end a copy of the original string of letters composing the complex message sent.

A rough explanation of the notion of the "selective information" associated with such a communication system would identify

6 Gombrich, influenced by Professor J. J. Gibson's writings on perception, has suggested that instead of speaking about "interpretation" we speak instead about how "the sensory system picks up and processes the *information* present in the energy distribution of the environment" (Gombrich 1969, p. 47). He adds that he is "fully alive to the danger of new words, especially fashionable words, becoming new toys of little cash value" (*ibid.*). But he relies strongly upon what he takes to be "the concept of information [as] developed in the theory of communication" (p. 50) throughout his article.

7 See Shannon and Weaver (1949) and Cherry (1966) for explanations of the technical theory. It is ironic that experts in information theory have repeatedly protested, apparently without success, about the misleading consequences of identifying what is called "information" in the technical theory with the meaning of that word in ordinary language.

8 See Cherry (1966), p. 308.

it with the amount of "reduction of initial uncertainty" that such a system can achieve. Suppose the various possible messages m_i are known to occur with long-run frequencies or probabilities p_i. We might say that the "information" conveyed by the receipt of a particular message, m_i, varies inversely as its initial probability of occurrence, p_i. For, the higher the initial probability of transmission, the "less we learn" by receiving the message. If the message in question were, in the limiting case, certain to arrive, we should "learn nothing" by receiving it. The mathematical quantity called the (selective) information is the measure of the amount of a certain magnitude—roughly speaking, the reduction in the amount of initial uncertainty of reception, as I have suggested above. It is important to stress that this has nothing to do with the meaning, if any, of such a message, and nothing to do even with its specific content. If I seek an answer to a question by means of a telegram, the only two possible answers being either Yes or No, and both being antecedently equally likely to be sent, then either answer contains the same "(selective) information." Each answer transforms a probability of 1/2 into certainty. An anxious suitor, awaiting an answer to his proposal of marriage, would of course say that the information received in the one case would be interestingly different from the information he would receive in the other. But that is because he is using "information" in the common or garden sense of what might be called *substantive* information. The theorists of the mathematical theory have no interest in substantive information—which is, of course, their privilege, and not a reproach. To think otherwise would be as misguided as to make it a reproach to a theory of measurement that it tells us nothing about the smell or taste of the masses discussed in that theory.

It would obviously be pointless to think of adapting this model to the case of representation. In place of the messages we should have to think of the original "scenes" corresponding to the representations, to which the long-term frequency of occurrence would have no sensible application. Even in some special case, say that in which male and female entrants to a college were photographed with stable long-range frequencies, the selective or statistical information attached to any photograph would tell us absolutely nothing about the photograph's subject or content—which is our present interest.

A few writers who have clearly seen the limited applicability of the statistical concept here called "selective information" have undertaken studies of what they call "semantic information," that might seem more useful for our purpose.[9] For it would seem that "semantic information," unlike selective (statistical) information, is concerned with the "content" or meaning of verbal representations (statements, texts). The theory of semantic information is presented as a rational reconstruction of what Hintikka calls "information in the most important sense of the word, viz., the sense in which it is used of whatever it is that meaningful sentences and other comparable combinations of symbols convey to one who understands them."[10] Now this seems to be just what we are looking for: the "displayed subject" of a photograph does seem close to what common sense would call the information that could be understood by a suitably competent receiver (viewer).[11] However, if we follow the constructions provided by Hintikka and other pioneers of "semantic information theory" we shall discover, to our disappointment, that they, too, provide something, of whatever interest, that will not help us in our present investigation. For it

[9] See especially Bar-Hillel (1964), Chapters 15–17, and Hintikka (1970). Bar-Hillel says: "It must be perfectly clear that *there is no logical connection whatsoever between these two measures, i.e., the amount of (semantic) information conveyed by a statement and the measure of rarity of kinds of symbol sequences* [our "selective information"], even if these symbol sequences are typographically identical with this statement" (p. 286, italics in original). And again, "*The concept of semantic information has intrinsically nothing to do with communication*" (p. 287, original italics)—and hence it has nothing to do with the concept of information that is defined relative to communication systems. On the other hand, Hintikka says he has "become increasingly sceptical concerning the possibility of drawing a hard-and-fast boundary between statistical information theory and the theory of semantic information" (p. 263). His suggestion that semantic information theory start with "the general idea that information equals elimination of uncertainty" (p. 264), a formula that would, as explained above, fit the case of selective (statistical) information, shows the link that Hintikka relies upon—in spite of Bar-Hillel's vigorous attempt to separate the two concepts.

[10] Hintikka 1970, p. 3.

[11] There is, to be sure, some violence done to ordinary language here. Common sense would reserve the use of "information" for what is conveyed by the photograph about the original scene. It would be paradoxical to think of the painting of an *imaginary* scene as providing information to anybody—just as paradoxical as supposing that *The Pickwick Papers* contains information about Mr. Pickwick.

turns out that the "semantic information" of a given statement is roughly the same as the range of verifying situations associated with that statement—or, more accurately, some measure of the "breadth" of that range. And here, what is finally provided is a measure of extent and not of content.

"Semantic information" is a sophisticated refinement of the common sense notion of the *amount* of information in a statement. Just as a report of a body's mass tells us nothing about what stuff that body is composed of, so a report of semantic information would tell us nothing about what the statement in question is *about*. If we have two statements of parallel logical structure, say, "My name is Black" and "My name is White,"[12] any acceptable definition of semantic information will assign the *same* semantic information to each statement. If this concept (whose interest I do not wish to deny) were applicable to paintings,[13] we should have to count distinct paintings with roughly comparable subjects (say, two paintings of a flock of grazing sheep) as having and conveying the "same information." But of course the displayed subjects of two such paintings might be manifestly different.

We need a term to distinguish what Hintikka, as we have seen, called "the most important sense of information," i.e., what we mean by that word in ordinary life: let us call it *substantive* information. And let us stretch the word to apply to false statements as well as to true ones (so that what would ordinarily be called "misinformation" also counts as substantive, but incorrect, information). What then could we mean by talking about the (substantive) information contained in a given photograph?

[12] On the plausible assumption that the two surnames occur with equal frequency in the populations in question.

[13] I do not think that anybody has yet tried to apply the concept of semantic information to visual representations. One difficulty, and perhaps not the most serious one, would be that of "articulating" a given verbal representation in a way to correspond to the articulation of statements in a given language into an ordered array of phonemes. Unless we can regard a photograph or a painting, by analogy, as composed of atomic characters, corresponding to phonemes, the desired analogy will hardly find a handhold. Then, of course, there is the lurking difficulty behind any attempt to assimilate paintings or other verbal representations to assertions with potential truth-value. This might serve for blueprints, graphs, and other representations designed to convey purported facts ("information" in the ordinary sense), but would hardly fit, without inordinate distortion, our prime case of paintings.

On the assumption that we have a sufficiently firm grip upon the notion of the substantive information contained in a *statement*, one might think of replacing the given photograph, P, by some complex statement, A, such that a competent receiver might learn just as much from A as from P, if P were to be a faithful record of the corresponding original scene. But surely there is something fanciful about this suggestion. Suppose somebody were to be presented with such a statement, A, and asked then to retrieve the photograph, P, of which it is supposed to be in some sense a translation, from a large set of different photographs. Is there good reason to think that such a task must be performable in principle? It seems to me, on the contrary, that the notion of a complete verbal translation of a photograph (and still more, the notion of a verbal translation of a painting) is a chimaera. A picture shows more than can be said—and not simply because the verbal lexicon is short of corresponding equivalents: it is not just a matter of the nonavailability of verbal names for the thousands of colours and forms that we can distinguish. But if so, the notion of information that has its habitat in connection with verbal representations (statements) will still fail to apply to the case that interests us.[14] In the end, it seems that what is picturesquely expressed by means of the figure of the "information" contained in a photograph or a painting comes to nothing else than what we mean when we talk about the "content" of the painting or "what it shows" (its displayed subject). There would be no objection to the introduction of a metaphor or analogy based upon information, if that provided any illumination. It seems to me, however, that this is not the case, and that reliance upon "information" on the basis of a more or less plausible analogy amounts in the end only to the introduction of a synonym—and a misleading one at that—for 'depicting' or 'representing.' It is not unfair to suggest that "the information conveyed by a painting" means nothing more than "what is shown (depicted, displayed) by that painting."

We may, nevertheless, draw a useful lesson from this abortive

[14] Of course, I do not wish to deny that we can put into words some of the things that we can learn from a faithful photograph. If anybody wants to express this by saying that information can be gleaned from such a photograph, there can be no harm in it. But we shall never in this way be able to identify the subject of the photograph. One is at this point strongly inclined to say that in some sense the visual subject can *only* be shown.

digression. One caution, stressed repeatedly by theorists of statistical and semantic information alike, is that the measures of information they discuss are always *relative* to a number of distinguishable factors in the relevant situations. In the case of statistical information, the amount of information is relative to the distribution of long-term frequencies of the system of possible messages transmissible in the communication channel in question; in the semantic case, the amount of information embodied in a statement is relative to the choice of a language and, on some treatments, to assumptions about given laws constituting an antecedent stock of given "information" to which any statement not inferrible from those laws makes an additional contribution. We might, therefore, be encouraged to draw a somewhat obvious moral: that however we come to identify or describe the substantive content of a painting or other visual representation, the answer will be relative to some postulated body of knowledge (concerning for instance the chosen schema of representation, the intentions of the painter or sign-producer, and so on). The idea that a painting or a photograph "contains" its content or subject as straightforwardly as a bucket contains water is too crude to deserve refutation. But ideas as crude as this have in the past controlled some of the discussions of our present topic.

Appeal to the producer's intentions. I shall now consider the suggestion that a way out of our difficulties might be found by invoking the intentions of the painter, photographer, or whoever it was that acted in such a way as to generate the visual representation whose "subject" we are canvassing. I do not know of any theorist who has based a full-fledged theory of representation on this idea, but corresponding theories of verbal representation are fairly common. Thus Professor Grice, in a well-known paper on "meaning,"[15] has urged that the meaning of an utterance can be analysed in terms of certain complex intentions to produce a certain effect in the hearer.[16] Again, Professor E. D. Hirsch, in a well-known

[15] See Grice (1957) and (1969) for the elaboration and modification of his position in reply to criticism.

[16] The details do not concern us here. The novelty in Grice's account consists in differentiating between a primary intention on the speaker's part to produce a certain belief or action in the hearer, and a secondary intention that recognition of that primary intention shall function as a reason for the hearer to comply with the primary intention.

book, has defined verbal meanings as "whatever someone has *willed* to convey by a particular sequence of linguistic signs and which can be conveyed (shared) by means of those linguistic signs."[17] There seems to be no reason in principle why this kind of approach should not be equally valid in connection with visual representation—or, indeed, in connection with any sort of representation at all.

The undeniable attraction of this kind of emphasis upon the producer's intention or "will" can be attributed to its tendency to remind us forcibly about the conceptual gap between the "interpretation" of some natural object (as when we infer from the characters of some trace to the properties of something that produced that trace), and the "interpretation" of a man-made object, intentionally created to have meaning or "content" of a sort that is accessible to a competent receiver. But to agree, in Grice's terminology, that the import of a painting is "non-natural" and not reducible to the termini of factual inferences from the vehicle is one thing; to suppose that the determinable subject of such a non-natural object can be defined in terms of features of the producer's intentions is something else that is far more problematic.

There is, to begin with, the immediate objection that the producer's intention, supposing it to have existed in some uncontroversial way, may misfire. Suppose I set out to draw a horse and, in my lack of skill, produce something that nobody could distinguish from a cow by simply looking; would it then necessarily be a drawing of a horse, just because that was what I had intended? Could I draw a horse by simply putting a dot on paper? If the answers were to be affirmative, we should have to regard the artist's intentions as having the peculiar character of infallibility: simply wanting a painting to be a painting of such-and-such would necessarily make it so. Surely this is too paradoxical to accept. Of a botched and unrecognizable drawing we should want to say "He intended to draw a horse, but failed" as we should say, in certain circumstances, of

[17] Hirsch (1967), p. 31. The reference to meaning as something that can be conveyed to and shared by others shows that Hirsch is not simplistically identifying the content of an utterance with the content of the speaker's intention. For elaboration of his views about this, see pp. 49–50 of his book. I have no quarrel with Hirsch's vigorous case for the need to refer to an author's intentions in providing adequate interpretations of a text.

any failed intention. The notion of intention involves the notion of possible failure.

A still more serious difficulty and one, if I am not mistaken, that is fatal to this approach, is that there is no way of identifying the relevant intention except by invoking the very notion of a subject of a possible painting that such reference to intention is supposed to clarify. Let us take the envisaged analysis in its crudest and least defensible form. Suppose the proposed analysis of "P depicts S" were to be "M, the producer of P, intended S to be a depiction of S." In this form, the logical circularity is patent: we could not understand the proposed analysis of depicting without already having a clear notion of that relation at our disposal. Nor could the invoked producer properly have any explicit intention to produce P as a depiction of S unless *he* independently understood what it would be like for the resulting P in fact to be a painting of S: to refer back to the intention that he would have if he were to be trying to make P depict S would enmesh him in hopeless circularity.[18]

The situation would be less objectionable, if the proposed analysis were to take the form: "P depicts S if and only if M, the producer of P, intended E," where E is imagined replaced by some complex expression (and not a straightforward synonym of 'P depicts S').[19] Then the circularity noted above would be absent. Only in order for this kind of analysis to be acceptable, E must have the same extension as 'P depicts S': we have captured the right intention only if what M intended to do was necessary and sufficient for P being a depiction of S (though not expressed in those words). And if so, we can then dispense with the reference to M's intention altogether, since "P depicts S if and only if E" will, by itself, constitute the analysis we were seeking. This way of looking

18 A similar point has been well made by Miss Anscombe (see Anscombe 1969). "If thinking you are getting married is essential to getting married, then mention of thinking you are getting married belongs in an explanation of what getting married is; but then won't an explanation of what getting married is be required if we are to give the content of thought when one is getting married?" (p. 61). With intention replacing thought, this is the structure of my own argument above.

19 This is, in fact, the structure of Grice's analysis of non-natural meaning, which is therefore not open to the charge of immediate circularity.

at the matter would also have the advantage of meeting the difficulty about the failed intention that we noticed above.[20]

I conclude that in spite of its attractions, the appeal to the producer's intention accomplishes nothing at all to our purpose.

Depiction as illusion. We have now considered three types of answers to our prime questions as to the analysis of a statement of the form 'P depicts S'. Of these, one, the reliance upon the "information" supposedly embodied in the representation, P, seemed empty, and the two others, in appealing to a causal history and the producer's intention respectively, invoked temporal antecedents that seemed only contingently connected with the final outcome.[21] We still need, it seems, to isolate something about *the representation itself* that will, in favorable circumstances, permit a qualified and competent viewer to perceive in the art object, without dubious inferences to antecedent provenance or partially fulfilled intentions,[22] something about P that makes it a painting of S and nothing else.

The reader may be surprised that I have waited until now to consider a famous answer that has behind it the authority of Aristotle and a thousand other theorists who have, in one form or another, endorsed his conception of art as mimesis. Let us try to formulate the conception of art as an "imitation of reality" in a way that will commit us to as little presupposed theory as possible.

Why not say that when I look at a naturalistic painting—say

[20] It might be an interesting feature of the logical grammar of 'depicts' if it were true that 'P depicts S' entailed 'The producer of P intended P to depict S'. (Cf. "That counts as a move in the game only if the player intended to make that move"—which need not be circular and may indeed be informative.) Unfortunately, even that is not true: the photograph may show much that its producer did not intend and would not even retroactively assimilate to his intention. There is such a thing as unintentional showing—as there is such a thing as unintentional speaking.

[21] This is not strictly true for the case of intention: what the artist successfully succeeded in achieving, in accordance with an embodied intention, does usually determine the intrinsic character of the product.

[22] We might say that the only intention that is relevant is the intention that the artist succeeded in embodying in the painting. Of course, a knowledge of the background—the tradition within which the artist was working, the purpose he had in mind, and other things—may well help us to "read" his painting, but the satisfactory reading must in the end be based upon what is there to be found in the painting.

of a white poodle on a sofa—it is *as if,* looking through the picture frame, I actually saw an animal having a certain appearance, resting on a piece of furniture at a certain distance from me. Of course, I know all the time that there is no such poodle in the place where I seem to see it; and that is what makes the experience an illusion, but not a delusion.[23] We are not really deceived, but we have had enough visual experience to know that we see *what it would be like* if the poodle were really there. There is a suspension of disbelief on the viewer's part, as there is when reading fiction, which describes non-existent persons *as if* they really existed. We might therefore speak of "fictive" or "illusive" vision in such cases.

The expression "as if," which I have used in my proposed formula, with its obtrusive reminder of "The Philosophy of As If," may smack of hocus-pocus. But this can be held in check, I think, and the expression treated as a harmless shorthand. To say "*A* is as if *B*" is simply to say "If *B* were the case, then *A*; but also not-*B*." In a case of illusion, the observer knows that not-*B*, in spite of appearances; in a case of deception or delusion, he believes that *B* is the case, contrary to fact. Thus the proposed analysis for our imagined case is: If there were a poodle of a certain sort and in a certain posture on a sofa at such and such a distance from me, I would see what I now see. Hence, I can see, here and now, what the subject of the picture is, without reference to the painting's aetiology, the artist's intentions, or anything else that is not immediately present. This account must certainly have some truth in it: a layman, in the presence of a painting by Claudio Bravo, will certainly report that it looks for all the world as if there were a parcel behind the surface, and a viewer, no matter how armored by theoretical commitments against the role of illusion, cannot avoid, if he is ingenuous, making a similar report for other cases of *trompe l'œil.* There is, of course, a serious question whether an account that seems to fit this special type of case can be extended,

[23] For views of this sort, see Gombrich (1961), passim. Given Professor Gombrich's illuminatingly rich and detailed discussions of "illusion" in his great book and elsewhere, I would hesitate to saddle him with any simple view about the role of illusion in art. That he seems to assign a central, though by no means exclusive, role to such illusion seems indicated by such references as "the illusion which a picture can give" (Gombrich 1969, p. 46). But he has always carefully distinguished, as I wish to do, "the difference between an illusion and a delusion" (*op. cit.*, p. 60).

without distortion or eventual tautology, to fit all cases of response to visual representations that are partially naturalistic. I think, however, that there is no serious difficulty in stretching the view to cover cases in which the presented subject is unfamiliar. There is no particular puzzle, on this view, in accounting for the viewer's sight of a flying horse or a fleshy goddess floating in the air. And the account can even be held to fit certain "abstract" works: if I see in a Rothko painting a receding plane bounded by a contrasting strip, and so on, that sight is not unlike what I have learned to see by looking at clouds. Similarly for Mondrian's *Manhattan Boogie-Woogie* or other such abstractions.[24]

On this view, puzzles about how a *P* can depict a determinate *S* reduce to questions about normal perception of the form "How is it that a real poodle can look like a poodle?" I am not sure what useful sense can be ascribed to a question of this form;[25] at any rate, it would fall outside the scope of our present inquiry.

Let us now consider possible objections. The first type consists in effect of the objection that the "illusion" is not, and is not intended to be, complete. As we shift our position with respect to the canvas, we do not get the systematic changes in appearance that would occur if there really were a live poodle in the indicated position: a painted canvas does not even produce as much "illusion" as a mirror. Furthermore, the presented visual appearance is "frozen," does not show the slight but perceptible changes to be seen in even a "still life," and so on.[26]

[24] I am not arguing that looking "through the surface" is a proper way of looking at all abstractions: in Mondrian's case, we know it would be contrary to his intentions. My point is only that the conception of depiction as illusion can cover a far wider range of cases than is sometimes assumed.

[25] The undoubted interest of this type of question for psychologists such as Professor J. J. Gibson (see, for instance, his 1968 book) arises from the need to explain how a flux of radiant energy, reaching the eyes, can be so processed that the viewer can correctly see the poodle as solid, at a certain distance from him, and so on. But answers to this kind of question, important as they are, are not our concern here. Cases of veridical experience are sufficiently familiar to be used as explanations for the more problematic cases of seeing *as if*.

[26] "As the eye passes over the picture, across the frame, to the wall on which it is placed, it cannot but become aware, however cunning the painting may be, of a discrepancy or discontinuity which is fatal to the illusion" (Wollheim 1963, p. 25). This assumes, without justification, that unless an illusion is total, it is not an illusion at all. Imagine an open aperture through which I could see an

The second type of objection draws our attention to the perceptible distortion to be noticed even in the most "realistic" paintings: in all but special cases, the sensitive viewer will see the brush strokes and will be aware, after all, that what he sees is not "very much like" the real thing.[27]

The undoubted presence of interfering and distorting features, even in the most "faithful" of paintings, is, up to a point, not serious for a defender of the theory that identifies depiction with illusion. Illusions need not be perfect and we have plenty of experience in genuine perception of discounting variations in appearance[28] and ignoring the effects of imperfections of the eye (floating specks, effects of myopia, and so on). Once we have learned *how* to look through the partially distorting medium of paintings and photographs, we shall simply see the depicted subjects as if they were really present.

But the real difficulties are concealed in the deceptive phrase, "once we have learned how things look," for this concedes in effect that in many cases there is a sense in which the subject does *not* look in the painting as it would if it were really present behind the canvas-plane—and such large deviations from ordinary vision cannot be written off by means of the retort we have just envisaged. If Picasso's women are to be seen *as* women (seen as if they were women behind the canvas) we shall have to learn a key of interpretation for which there is no analogue in normal perception. For instance, we shall have to learn to distinguish between a "faithful" painting of a green face and a green painting of a white face. But once we allow, as we must, for such prior induction into the "tech-

actual landscape outside: then what happened as my eye passed over the walls and so on would not prevent me from saying that I saw the landscape.

[27] Cf. the reaction of Roy Campbell on first seeing snow, having seen only paintings of it before: "From paintings I had imagined it to be like wax, and snow flakes to be like shavings of candle grease" (quoted from Gombrich 1961, p. 221).

[28] Cf. the famous "constancy phenomenon" (for which see, for instance, Hochberg 1964, p. 50). We see a poodle—indeed the same poodle, from different angles, at different distances, and in various lights. Then why should we not be able to see the poodle through whatever distortions are due to the artistic medium and the artist's handling of it? If we can recognize the poodle in moonlight, or even in a trick mirror, then why not when it is, as it were, seen through a painting darkly?

nique of representation," the equation of depiction with fictive representation or "illusion" loses its attraction. Instead of saying "*P* is a representation of *S* because seeing *P* is, with some reservations for incompleteness and distortion, like looking at *S* (seeing *P* is as if one were seeing *S*)," we now have to say something like: "In general, *P* is a representation of *S*, if *P* looks like *S*, according to the conventions embodied in the artist's style and technique." And now, one wonders how much work the surviving reference to "looking as if *S* were present" really does. Given a case of extreme distortion, is it still necessary to say that we see, and are required to see, something that looks as if it were behind the canvas? Is this not perhaps only a misleading way of making the obvious point that if we have learned how Picasso in his cubistic period painted a woman, we shall *know* that the painting is of a woman?[29] Is anything added by the insistence that we also "see the painting as if" it were something really there? I am inclined to think that by the time the theory has been stretched so far it has degenerated into useless mythology.

Finally, we might notice that the view under examination can be regarded as reducing "depicting" to "looking-like." For instead of saying that *P* is seen as if *S* were present, one might as well say that *P* "looks like *S*" (although we know that *S* is not present). Most defenders of an illusion theory have indeed supposed some view concerning resemblance between a picture and its subject to be at its foundation. But this deserves separate examination.

Depiction as resemblance. We have seen that any tenable conception of depiction as involving a sort of illusion (seeing the painting's subject *as if* it were present) must provide room for the observable differences, ranging all the way from selection to outright distortion, between the subject as represented and as it would appear if actually present. Only when delusion or deception is the controlling aim of the artist, do we get even an approximation to total "imitation." Now a favored way of allowing for the element

[29] Even in a very distorted representation, we can sometimes analyze the particular elements that are operative, picking out one outline or color patch as the face, another as the arm, and so on (but it does not seem necessary that we should always be able to do this). Reliance upon such clues, if that is what they should be regarded as being, does not fit easily into the conception we are here examining.

of unlikeness in even the most "faithful" visual picture is to invoke a notion of *resemblance*: the picture is not conceived now as "looking as if" the subject were present, but rather as looking as if something *like*, something resembling, the subject were present.

A typical statement of this standpoint is the following by Professor Beardsley: " 'The design *X* depicts an object *Y*' means '*X* contains some area that is more similar to the visual appearance of *Y*'s than to objects of any other class.' "[30]

On a certain rather simplistic conception of similarity or resemblance (which I take to be synonyms in the present context), it is easy to launch devastating objections to any attempt to make resemblance central to the relation of depiction. For one thing, a photograph or a painting, considered as physical objects, are really not at all like horses or trees or oceans, and there is something askew in supposing a "design" to be more "similar" to a tree than to an ocean. (Cf. asking whether a postage stamp is more similar to a person than to a piece of cheese.) But if we take Beardsley's formula as a careless way of saying that the *look* or appearance of the "design" has to be "more similar" to the *look* of a tree than to the look of an ocean, we are at once enmeshed in all the conceptual difficulties that attend any conception of comparisons between such dubious entities as "looks."[31]

We need not enter upon this controversial range of questions, since the superficial logical structure of the verb 'to resemble' makes any resemblance view excessively implausible. To take only a single point: we tend to think of the relation of resemblance or similarity as symmetrical. If *A* resembles *B*, then necessarily *B* re-

[30] Beardsley (1958), p. 270. I do not wish to saddle Beardsley with some version of the depicting-as-illusion view. An adherent of the conception that the essence of faithful naturalistic depiction is to be found in some relation of resemblance need not be committed to any opinions about the resulting "illusion," although the two conceptions fit well together.

[31] The archetypical situation of our crudest conceptions of resemblance, as arising from comparisons of objects, is that of having the two objects side by side and looking at each in turn, in order to "perceive" relevant resemblances. But then the "comparison" of appearances would require a kind of second-order looking at looks. Perhaps this can sometimes be achieved. However, it seems remote from what happens when we see something in a painting as a horse. We do not in the mind's self-observing eye compare the look of what we now see with the look that we should see if we were faced with a horse. To say "That looks like a horse" refers surely to some more primitive operation.

sembles *A*, and both resemble one another.[32] However, if we take this seriously, we shall find ourselves committed to saying that any tree is a representation of any naturalistic picture of a tree. And since nothing resembles a painting so much as a reproduction of it, the absurdity lurks close at hand of identifying the subject of any picture with its copy.[33]

Further objections to a resemblance model. The well-known objections, restated above, to regarding resemblance as the basis of naturalistic depiction, might well leave us unsatisfied. We might have an uneasy feeling that appeal to the surface grammar of 're-semblance' is too summary a way of disposing of a putative insight. To be sure, if we treat resemblance as symmetrical and transitive, we shall be saddled with paradoxical consequences; but is there not, after all, we might still think, *something* to the notion that a naturalistic photograph "resembles" or "looks like"[34] its subject? And if so, could we not modify the superficial implications to preserve this insight? If ordinary language commits us to saying, for instance, that in some sense of resemblance a painting resembles nothing as much as itself, is it beyond the wit of man to establish a more appropriate sense of the crucial expression? It will be worth our while to probe more deeply.

Our common, simplifying, conception of "resemblance" is controlled, I would like to suggest, by one or more "pictures"[35] or

[32] It is important that these logical features are not always exemplified in the ordinary language uses of 'look like'. When *A* looks like *B*, *B* need not look like *A*, and the two need not look alike. It is this kind of point that makes any easy reference to resemblance or similarity (as a substitute for the less pretentious but more relevant notion of looking-like) so unsatisfactory.

[33] This kind of objection has often been made before. "An object resembles itself to the maximum degree but rarely represents itself; resemblance, unlike representation [= depiction, in this context] is symmetric.... Plainly, resemblance in any degree is no sufficient condition for representation" (Goodman 1968, p. 4).

[34] I do not mean to imply that these two expressions can always replace one another. Indeed, I shall soon argue that the associated patterns of use show important differences.

[35] I am using this word here in somewhat the way that Wittgenstein often did in his later writings. Cf. such a characteristic remark as "The *picture* of a special atmosphere forced itself upon me" (Wittgenstein 1953, p. 158). Wittgenstein's notion of a "picture" deserves more attention than it has yet received. Many of our key words are associated with what might be called semantic myths, conceptions of exemplary and archetypical cases in which the use of an expression

idealized prototypes of application. Consider the following simple examples of clear cases of "resemblance":

1. A writer is buying a new supply of typing paper in an unfamiliar shop. He *compares* a sheet that is offered him with one from his old and nearly exhausted stock. "That is *rather like* what I want; but that is better; perhaps that *resembles* what I need sufficiently closely."

2. A housewife goes to a shop to buy some extra material for a dress she is making: she compares the material *in imagination* with what she already has. "That *looks almost* like what I need; it *resembles* it very closely; I think it will do."

3. A film producer needs a stand-in for his principal actor in some dangerous sequence. He *compares* the two men, deciding whether the substitute sufficiently *resembles* the star, so that the audience will not detect the substitution.

4. A historian compares the careers of Hitler and Stalin for *"points of resemblance."*

5. In trying to sway a judge, an advocate offers a previously decided case as a precedent, but is met with the objection, "I don't see sufficient resemblance between the cases."

Such examples and the many others that could easily be produced suggest the following reflections:

a. The notion of resemblance is closely connected with the notions of *comparison* and *matching* (also with that of *similarity*, which I shall here ignore). In some of the cases, but not in others, the ideal limit of the scale of relative resemblance is that of indistinguishability: if the writer could not tell the new paper apart from the old, he would surely be satisfied, though he would be willing to accept something less satisfactory. And similarly, *mutatis mutandis*, for cases 2 and 3.

b. In other cases, the degree of "resemblance" in the things compared turns upon point-to-point correspondences, so that there

seems to be manifested in excelsis. Such an archetypical situation is not merely a paradigm but, as it were, a paradigm of paradigms, wherein we think we can grasp the essence of the expression's meaning in a single flash of insight. It is as if the extraordinary complexity of the expression's actual use were compressed into a dramatic and memorable fiction. To the extent that we are dominated by such a primeval myth, we are led to procrustean conceptualization—a cramping, because over-simplified, conception of the word's meaning. (Of course, Wittgenstein has said this far better.)

is an observed *analogy* between the things compared, while indistinguishability is not in question (cases 4 and 5).

c. What determines the choice of specific criteria of degree of resemblance in a particular case results from the overarching purpose of the particular process of matching or analogical comparison: sometimes it is a question of finding an acceptable *surrogate*, with respect to appearance, durability, or other properties; sometimes a matter of finding a justification for applying general concepts, dicta, maxims, or principles (cases 4 and 5). In short, what counts as a sufficient degree of resemblance, and the respects in which features of resemblance are treated as relevant, is strongly determined by the overall purpose of the process. To put the point negatively: in the absence of such a purpose, any proposed process of comparison is indeterminate and idle. If I am asked to compare *A* with *B*, or to say how much resemblance there is between them, in the absence of any indication of what the comparison is to be used for, I do not know how to proceed. Of course, if politeness requires me to make some response, I may invent some purposive context, trying to assimilate the task to some familiar case, and hence seeking for points of color resemblance, or similarity of function, or whatever else ingenuity may suggest.

Of the points I have singled out for emphasis, the first two serve mainly to remind us of the great variety of procedures that are covered by the umbrella term "resemblance": that compendious label covers a large variety of processes of matching and analogy-drawing, performed in indefinitely many ways and for indefinitely many purposes, with corresponding variety in what counts as appropriate and relevant to the comparison procedures. But the third point, stressing the relativity of comparision with relation to some controlling purpose, is the crucial one for the present inquiry. It is quite opposed in tendency to the picture we have of "resemblance" being constituted by the sharing of common properties, as if we could decide the question whether one thing were or were not similar to another *in vacuo*, without any reference to the aim of the exercise. (Cf. asking whether *A* is better than *B*, which also demands a comparison, in the absence of further determination of the question's sense.)

Let us now apply these elementary reflections to our prime case of the painting and its subject. The first obstacle to using

either pattern of resemblance (the search for an approximate match or the search for an analogical structure) is, as we have already seen, that the "subject" is normally not available for independent scrutiny. When the painting is "fictive," there can be no question of placing it side-by-side with its subject in order to check off "points of resemblance." But let this pass, though the point is far from trivial: it remains that the determining purpose of the imputed comparison is left unstated. What is the *point* of my looking first at a portrait of Queen Elizabeth and then at the queen herself, in order to find points of resemblance? There can be no question here of the painting being a surrogate for the person, as in some of our exemplary cases. Nor can it be a matter of being able to make corresponding statements about the two, though that *might* be the point, if the portrait were to be preserved in some historical archive to supplement and amplify some verbal description. We are left with nothing better than the empty formula that the painting should "look like" the sitter. But that is merely to substitute the unanalyzed expression "looks like" for our problematic expression "resembles." Here again, the point about the absence of determination of purpose is relevant. Given that for some purposes and in some contexts the most naturalistic *trompe l'œil* portrait will look conspicuously unlike a person, what is to *count* as "looking like"? Whatever merits the resemblance view might have, it cannot provide answers to these questions.

My chief objection to the resemblance view, then, is that when pursued it turns out to be uninformative, offering a trivial verbal substitution in place of insight. (In this respect it is like the view of depiction as the expression of "information" previously discussed.) The objection to saying that some paintings resemble their subjects is not that they don't, but rather that so little is said when only this has been said.

"Looking like". I have agreed that stress upon "resemblance," however philosophically uninformative in the end, does at least serve the useful purpose of reminding us how the fact that a painting resembles something *in the sense of looking like it* may be relevant. It would be a willful violation of common sense to say, for instance, that whether a photograph "looks like" a tree, a man, or whatever the case may be, has *nothing* to do with its function as a picture. Certainly a picture may "look like" its subject, but the

problem is to see whether we can say anything useful about what "looking like" amounts to. So it should be worth our while to examine somewhat more closely the notions connected with the expression "looking like" or its grammatical variants.

Here we shall immediately find, as in the case of the words connected with 'resemblance', that there are paradigmatic uses that need to be distinguished. So let us begin again with some examples.

1. We are meeting somebody at the station. Pointing to someone approaching in the distance, you say, "That looks like him."

2. On meeting twin brothers, you say "Tom does look very much like Henry, doesn't he?"

3. Of a cloud: "Look at that: doesn't it look like a bird?"

4. We might say of a man: "He looks very much like a wolf."

The first type of case might be identified as one of *seeming*. It can sharply be distinguished from the others by the possibility of substituting the phrase "looks as if," with corresponding adjustment in the rest of the utterance. Thus, in case 1, little if any difference would result from saying "That looks *as if it* were him." Two other grammatical points may be made. If we try to insert adverbial qualification, as in "That looks *very much* like him," we may justifiably feel that we are shifting to another use: thus to the latter remark, but not to the original one I have imagined, it might be natural to reply, "I don't see the resemblance." A connected point is the difficulty of negating the original remark: If I want to disagree with "That looks like him," in the intended use, the best I can do is to say, "No, that does not look like him" or "I don't think so"—while "No, that looks unlike him" has, in context, the feel of playing on words. For present purposes, we may think of this first use of 'looks like' as connected with qualified assertion: the whole utterance has the force of expressing a weak truth-claim, with the implication of lack of sufficient and conclusive reason. (Cf. the form "That might be him.") I note this use only to exclude it from further consideration, since it obviously has no application to our prime subject: there is normally no occasion to make qualified assertions about the subject of a painting or picture.[36]

36 An exception might be a case in which we were trying to identify the sitter of some portrait or the actual scene of some landscape. In such special case we might say "It looks like Borgia" or "It looks like Salisbury Plain." That would imply the presence of some visual evidence for the identification in question.

The second type of case is the one already discussed, in which explicit and even point-by-point matching is present or in the offing. Here, reference to "resemblance," in uses close to some that we previously listed, is appropriate.

In the third case (the cloud "looking like a bird"), I should want to argue that the attempt to assimilate it with full-blooded matching would be a distortion. For one thing, we seem here to be engaged in some kind of indirect *attribution*, rather than in some implicit comparison. For instance, a supplementary question of the form "Like *which* bird?" would be rejected as stupid, unless taken to be a request for further specification of the attribute (an eagle, rather than merely a bird). Here, it is worth emphasizing that recourse to "points of resemblance" will seem particularly out of place; indeed, the form of words "Look at that cloud: doesn't it *resemble* a bird?" will feel like a shift to the previous type of use.[37] One might say that, in certain cases of this type, the speaker is more or less indirectly describing the situation *before him*. It is as if, given the task of describing the cloud in terms of an animal, he were to say "If I *had* to describe it as some kind of animal, the only one that would fit would be 'a bird'." There are some obvious analogies here to the use of metaphor, as contrasted with the use of simile: *looking-like* in the context of attribution, rather than comparison, is closer to metaphor than to simile.

Finally, there are cases like the last ("He looks like a wolf"), where the suggestion of comparison, which is admittedly still present, is so far suppressed as to have almost no effect. Saying of a man that "He looks like a wolf" or, alternatively, "He has a wolfish look" may be a way of recording an immediate impression, with no thought of being able to specify points of resemblance— or, in some cases, of being able to specify *any* ground for description. In such cases we might be said to be dealing with *non-exponible* metaphor or catachresis. On being challenged as to the propriety of our description, perhaps the best we can say is that it seems to fit—which is, of course, saying very little.

[37] An obstacle to making this kind of point persuasively is that uses of the words I am discussing are more elastic and variable than I may seem to be contending. I do not doubt that 'resembles' can sometimes and without impropriety or ambiguity be used as a contextual synonym for 'looks like'. Yet, if I am not mistaken, the differences in use that I am trying to emphasize really exist and could be fixed more sharply in a longer and more laborious investigation.

The chief moral that I wish to draw from this brief examination of some related uses of 'looks like' is that if we had to position in our schema the use of such a sentence as "That looks like a sheep" (said while pointing to a picture), we should do well to choose the last of our four types. If one says of a painting, or part of one, "That looks like a man," one is normally not saying that there is partial but incomplete evidence for its being a man (which would be preposterous), nor that there are exponible points of resemblance between that patch of painting and a man (which is highly implausible and, in the absence of any assignable point to the comparison, idle), nor attributing a property to that patch as one might, by way of simile, call a cloud bird-like, but rather saying something about that very thing before us, as we say of a man that he has a wolfish look, intending to say something directly about him—and not about a certain imputed relation to wolves. If so, the sense in which a realistic painting "looks like" its subject still resists analysis. One might even be inclined to say, indeed, that that expression ought to be avoided, as tending to have misleading suggestions.

If a child were to ask how one would learn to find out whether a canvas "looks like" a man, perhaps the best we could say is, "Watch a painter at work on his canvas and then, in the end, perhaps you will really *see* a man when you look at the painting." But if that is the best that we can say (as I believe), it looks as if the fruits of our analytical investigation are, after all, very meagre.

A landing place. I have now completed the task of examining the credentials of plausible candidates for the role of a necessary condition for the holding of the relation of "depiction." I have satisfied myself, and perhaps the reader also, that none of the criteria examined will supply a necessary condition.

Appeal to the "causal history" of a photograph or a naturalistic painting came to look like the invocation of contingent factual circumstances that may in fact be needed for the production of a terminal visual representation, but do not determine its character as a picture by virtue of logical or linguistic necessity. By considering extraordinary, but logically possible, cases in which deviant causal histories might produce pictures indistinguishable from our paradigms of faithful likenesses, we were able to eliminate appeal to a causal history of a special kind as a necessary or a sufficient

condition. The same verdict, however disappointing, was all that emerged from our examination of the other criteria. Reference to the imputed intentions of the picture's producer seemed enmeshed in hopeless circularity, since the very specification of such an intention required independent specification of what would count as fulfilling the producer's intention. The seductive model of "information," factitiously borrowing prestige from an irrelevant mathematical theory, proved a will-o'-the-wisp, amounting in the end to no more than a linguistic rechristening of the problematic concept of "depiction." Finally, reliance upon the attractive notion of "resemblance" between a picture and its "subject" left us, once we had unravelled the skein of criteria concealed by the deceptive surface unity of the abstract label of "resemblance," with nothing more than our original problem, under the guise of questions as to what it really means to say that a picture "looks like" what it represents, in the crucial cases in which "looking like" cannot properly be assimilated to point-to-point matching with some independently given object of comparison.

Are we then left empty-handed? Should we confess that the investigation we undertook has been a complete failure, with no hope of improvement? Such conclusions would, in my judgement, be too hasty. For the point needs to be made, and with emphasis, that the disqualification of some proposed condition as a necessary and sufficient criterion by no means shows that condition to be *irrelevant* to the application of the concept in question.

It would, for instance, be quite wrong to suppose that knowledge of how photographs are regularly produced, and of the perceptible changes that occur in the series: displayed scene, negative, and final positive, have *nothing* to do with our ultimate judgement of the photograph's representative content. On the contrary, our mastery of the skill of interpreting or "reading" photographs depends essentially upon our schematic knowledge of how such photographs are *in fact* normally produced.[38] It is through our knowledge of

[38] One might conjecture that a factor in the alleged inability of members of primitive cultures to understand photographs on first seeing them may be partly due to such ignorance of the mode of production. If these bewildered would-be interpreters were allowed to follow through the stages of production, with a chance to compare the negative with the external world, they might begin to have a clue to what Professor Stenius has called the "key" of the relevant system of representation (cf. Stenius 1960, p. 93, where the useful term "key" is

the photograph's provenance that we understand what the photo-graph "shows." In cases of mysterious provenance, as when a lay-man looks at an X-ray photograph, the absence of relevant factual knowledge of aetiology obnubilates comprehension. Indeed, in dis-puted or ambiguous cases, specific reference to the circumstances of production may be necessary in order to determine *what* the subject is.[39]

Similar remarks apply to the currently discredited appeal to the producer's intentions.[40] Although we cannot define "depiction" or "verbal representation" in terms of intention without vicious circularity, it may be altogether proper, indeed sometimes essen-tial, to refer back to the producer's intentions in order to be able to read the very picture in which his intentions, to the extent that they were successful, were ultimately embodied. Here, as before, to pretend that we could ever learn to understand photographs or paintings without repeated reference to what photographers and painters were trying to achieve would be unrealistic.

Finally, similar points can be made about "resemblance" and "looking like." Our justified qualms about the capacity of these to provide defining conditions for the overall concept must not be allowed to obscure the utility, at times, of relying upon point to point comparisons or—to jump to something different—to the "way the picture looks" or simply to "what we inescapably see in the picture."

however used in a somewhat more restricted sense). For reports of the inability of primitives to "understand" photographs, see for instance Segall et al. (1966), pp. 32–34.

[39] Some interesting examples will be found in Gombrich (1969). We should, for example, not know what to make of his illustration of the "Tracks of an oyster catcher" without the accompanying commentary (pp. 35–36)—which explains, *inter alia*, that the bird shown was superimposed on a photograph by an artist. Our knowledge of this unusual causal history materially influences our "reading." Consider also the cases, discussed by Gombrich in the same paper, in which we need to "interpret" photographs of deliberately camouflaged objects (pp. 37 ff.). I agree with Gombrich that "knowledge, a well-stocked mind, is clearly the key to the practice of interpretation" (p. 37). But I think it is also *a* key to the mastery of the relevant *concept* of interpretation.

[40] This is hardly the place to discuss the so-called "Intentional Fallacy" that has been memorably castigated in Wimsatt (1954). Professor Hirsch makes the useful and commonly overlooked point that Wimsatt (and his collaborator Monroe Beardsley) "carefully distinguished between three types of intentional evidence, acknowledging that two of them are proper and admissible" (Hirsch 1967, p. 11).

The proper moral to be drawn from the initially disconcerting outcome of our investigation is that the notion of "depicting" is what has been called a "range concept" or a "cluster concept."[41] The criteria we have considered—and perhaps others we have overlooked—form a skein, none of them being separately necessary or sufficient, but each of them relevant in the sense of potentially counting toward the proper application of the concept of depiction. In perfectly clear cases, all of the relevant criteria point together toward the same judgment, whether we rely upon what we know about the method of production, the intentions of the producer, or the sheer "look" of the picture as it appears to a competent viewer who sufficiently knows the tradition within which the picture is placed.[42]

A reader who might agree with this kind of moral might still perhaps wonder why, if "depicting" is properly to be viewed as a "range-" or "cluster-concept," just *these* criteria should have been "clustered" together. One answer might be to invite such a questioner to undertake the *Gedankenexperiment* of imagining conditions in which the criteria were disassociated.[43] The point of *our* concept of depiction— the "only" concept we have—might then become plainer. But such an answer, whatever its pedagogical merits, is somewhat evasive.

There is something of the first importance lacking from our account, namely all consideration of the purposes of the activities in the course of which, what we, in our culture, recognize as "pictures" are produced. And no account of the concept of depicting, or of the various related concepts bundled together under that label, could be adequate without some examination of such purposes.

This weakness in our discussion might even be felt in connec-

[41] For the general methodology of handling such concepts, see Black (1954), chapter 2.

[42] Hard cases of "interpretation" typically arise when there is a real or apparent conflict between the defining criteria. When, for instance, we have firm evidence of the producer's intentions and of the means for realizing his intentions within the tradition to which he adheres, but cannot yet "see" the desired embodiment in the picture itself and do not know whether to blame the artist or ourselves.

[43] For instance, by imagining, *in full detail*, what the situation would be in a "tribe" (that convenient mental construct) whose members were keenly interested in "seen" likenesses, in total disregard of the intentions or modes of productions responsible for such objects.

tion with our account of how photographs depict. Photographs have been talked about in this essay as if they were objects having no identifiable uses and consequently no intelligible interest. But we are obviously keenly interested in photographs, and for a variety of reasons. If we focus upon one such interest, say that of *identifying persons* (as in passport photographs), we shall not find it difficult to see why some of our criteria harmonize with that purpose. Of course, it is by no means easy to formulate, with any show of thoroughness, the many purposes that photographs serve in our culture; and when we pass to the more difficult realm of art objects, the difficulties multiply. But the moral to be drawn is that clarity about the basic notion of artistic representation cannot be expected to be reached by a process of logical analysis alone, however sophisticated in its apparatus of "cluster concepts" and "family resemblances," but will call for a less tidy and more exacting inquiry into the production and appreciation of art objects within "ways of life." But this is hardly the place for what is already too long a discussion.[44]

44 One of the great merits of Professor Wollheim's stimulating little book on aesthetics (Wollheim 1968) is that he initiates such discussion.

Anscombe, G. E. M. "On promising and its justice, and whether it needs be respected *in foro interno."* *Critica* 3 (April/May 1969).

Austin, John L. "The Meaning of a Word." In his *Philosophical Papers*, ed. J. O. Urmson and G. J. Warnock. Oxford: The Clarendon Press, 1961.

Bar-Hillel, Yehoshua. *Language and Information.* Reading, Mass.: Addison-Wesley Publishing Company, 1964.

Beardsley, Monroe C. *Aesthetics.* New York: Harcourt, Brace and Company, 1958.

Black, Max. *Problems of Analysis.* London: Routledge & Kegan Paul, 1954.

Cherry, Colin. *On Human Communication.* 2nd ed. Cambridge, Mass.: MIT Press, 1966.

Gibson, James J. *The Senses Considered as Perceptual Systems.* Boston: Houghton Mifflin Company, 1966.

Gombrich, E. H. *Art and Illusion.* Revised ed. Princeton: Princeton University Press, 1961.

———. "The Evidence of Images." In *Interpretation, Theory and Practice,* ed. Charles Singleton. Baltimore: Johns Hopkins Press, 1969.

Goodman, Nelson. *Languages of Art.* Indianapolis and New York: The Bobbs-Merrill Company, 1968.

Grice, H. P. "Meaning." *The Philosophical Review* 66 (July 1957).

———. "Utterer's Meaning and Intention." *The Philosophical Review* 78 (April 1969).

Hintikka, Jaakko. "On Semantic Information." In *Information and Inference,* ed. J. Hintikka and P. Suppes. Dordrecht: D. Reidel Publishing Company, 1970.

Hirsch, E. D. *Validity in Interpretation.* New Haven: Yale University Press, 1967.

Hochberg, Julian E. *Perception.* Englewood Cliffs, N. J.: Prentice-Hall, Inc., 1964.

Segall, Marshall H.; Campbell, Donald; and Herskovits, Melville J. *The Influence of Culture on Visual Perception.* Indianapolis and New York: The Bobbs-Merrill Company, 1966.

Shannon, Claude E., and Weaver, Warren. *The Mathematical Theory of Communication.* Urbana, Ill.: University of Illinois Press, 1949.

Stenius, Erik. *Wittgenstein's 'Tractatus'.* Oxford: Basil Blackwell, 1960.

Wimsatt, William K., Jr. *The Verbal Icon.* Lexington, Ky.: University of Kentucky Press, 1954.

Wittgenstein, Ludwig. *Philosophical Investigations.* Oxford: Basil Blackwell, 1953.

Wollheim, Richard. "Art and Illusion." *British Journal of Aesthetics* 3 (January 1963).

———. *Art and Its Objects.* New York: Harper & Row, 1968.

postscript

Having been accorded the honor of opening this series of Thalheimer Lectures, I am doubly grateful to the editor for his invitation to add a brief postscript to this new edition in paperback. For he who starts inevitably cannot foresee what turn the discussion will take. Those who followed were able to refer to the text of my paper, albeit not in its final form, which is now before the reader. Having meanwhile studied their contributions with profit and interest, I naturally regret that I cannot take up their arguments in my turn, just as I am sorry that my final version was not in their hands before they sent theirs to the printers. To mention only two instances—at least one of the logical points concerning resemblance made by Professor Black (p. 118) has also been touched upon by me (p. 7), while Professor Hochberg's important remarks on expressive consistency might conceivably have been qualified in the light of the problem I raised earlier (p. 21).

It will also be seen by comparing the bibliographies of the second and third lectures that the two authors were not cognizant of the same specialised papers in which I returned to the problems

of *Art and Illusion*. Had Professor Black known my article on "The 'What' and the 'How'," listed by Hochberg (p. 93), he might perhaps have slightly modified his last paragraph (p. 115), for it deals precisely with the 'illusion' of shifts in the orientation of represented objects. I also hope that Professor Hochberg might have wanted at least to comment on the experiment I illustrated in "The Evidence of Images" (quoted by Black, p. 130), in which I showed what happens to the "impossible" tuning fork if we shorten the rods so that the whole configuration can be taken in at one glance.

In my book on *Art and Illusion* I noted with satisfaction that the position at which I had arrived vis-à-vis the Gestalt Theory "converged" with that of Professor Hochberg, a fact to which I subsequently drew specific attention in the preface to the second edition of the book. Naturally, I was pleased to find this conviction confirmed when reading Hochberg's contribution to this volume. In my book (p. 228) I had talked of "the possibility that all recognition of images is connected with projections and visual anticipations." I elaborated this view in an article "How to Read a Painting" (originally published in the *Saturday Evening Post* 234 [1961], reprinted under the title "Illusion and Visual Deadlock" in my *Meditations on a Hobby Horse* [London, 1963]), where I wrote that "reading a picture is a piecemeal affair that starts with random shots and these are followed by the search for a coherent whole.... The eye... scans the page, and the cues or messages it elicits are used by the questioning mind to narrow down our uncertainties." Not that these "convergences" are mysterious. We have both profited from that theory of information which Professor Black wants us to eschew in the discussion of non-statistical problems. His impatience is understandable and the dangers of confusion undeniable. But dare one suggest that even his own problem of the creation of a resemblance can on occasion be profitably studied in terms of that game of "twenty questions" that has become the primer of information theory? I am referring to the composite pictures of "wanted" men, known as "identikit," in which it is precisely "selective information" that is used. I fully agree with the spirit of Professor Black's last paragraph that here as always we must pay regard to the context and use of a representation; but would we not get a little further if we took more account of that experience of recogni-

tion which may also fit his example of the person who "looks like a wolf" (p. 124)?

In a lecture on "Visual Discovery through Art" (*The Arts Magazine*, November 1965, reprinted in J. Hogg, ed., *Psychology and the Visual Arts* [Harmondsworth, Middlesex, 1969]) I placed the concept of recognition in the center of the discussion. To what an extent the signals of recognition which specially interested me in my paper for this volume may have a bodily concomitant must admittedly remain a matter for future research. But, somewhere, I would contend, there must be a transformer in our nervous system that can convert visual impressions into patterns of innervations. How else could we learn by looking? To go on here would be less than fair to my fellow symposiasts. There must be an end, not to the debate, of course, but to this postscript.

index

Karsh, Yosuf, 17, 20
Kitkat Club, 14
Kokoschka, Oskar, 41, 42 (fig. 32), 43 (fig. 33)
Kris, Ernst, 36n

Laban, Ferdinand, 33n
Lake, Carlton, 30n
Lashley, K. S., 63
La Tour, Maurice Quentin de, 21, 22 (fig. 18)
Lawrence, Thomas, 40
Le Brun, Charles, 3, 5 (fig. 2)
Lee, Vernon, 35
Lenbach, Franz, 16, 18 (fig. 15)
Leonardo da Vinci, 21, 47–49, 53–54, 59, 61, 91
Leyhausen, Paul, 34n
Lichtenberg, Georg Christoph, 36
Liebermann, Max, 46
Liszt, Franz, 16, 18 (figs. 14, 15)
Lippi, Filippino, 2
Lipps, Theodor, 35, 78, 80
Locke, John, 37
Lorenz, Konrad, 34n, 40
Louis Philippe, 38, 40
Low, David, 10 (fig. 7), 11

Marazza, A., 40n
Masaryk, Thomas, 41, 43 (figs. 33, 34)
Matisse, Henri, 28
Metzger, W., 72
Michelangelo, 2
Miller, George A., 63
Modigliani, Amedeo, 79
Mondrian, Pieter, 115
Montagu, Jennifer, 5n
Munch, Edvard, 79, 83

Nadar, F. T., 16, 18 (fig. 14)
Nordenfalk, Carl, 2n

Orpen, William, 3n, 34n

Panofsky, Erwin, 2n
Payne, W. A., 3n
Penrose, Francis Cranmer, 59
Petrarch, 8, 24, 36
Philipon, Charles, 38, 39 (fig. 31)
Picasso, Pablo, 28, 29 (fig. 27), 30, 116, 117
Pierce, J. R., 3n
Piles, Roger de, 21
Pirenne, M. H., 59, 77
Pollack, I., 68

Pope-Hennessy, John, 2n
Porta, G. B. della, 34, 35 (fig. 30)

Raphael, 2
Reiter, L., 90
Rembrandt van Rijn, 5, 41–42, 44 (fig. 35), 45 (fig. 36)
Reynolds, Joshua, 21
Richter, Sviatoslav, 19 (figs. 16a, b)
Riggs, L. A., 72
Robertson, Janet, 23, 26
Rothko, Mark, 115
Russell, Bertrand, 6 (fig. 3), 6–7, 7 (fig. 4), 38
Ryan, T., 74, 78, 90

Samuels, F., 90
Schacht, Hjalmar, 12–13, 13 (figs. 10, 11)
Scharf, Alfred, 2n
Schlosser, Julius von, 2n, 22n
Schwartz, C., 74, 78, 90
Secord, P. F., 88
Segall, Marshall H., 127n
Shahn, Ben, 2n
Shannon, Claude E., 105
Shinwell, Emanuel, 3, 4 (fig. 1)
Singleton, Charles S., 30n
Steichen, Edward, 21–22
Stenius, Erik, 126n
Stravinsky, Igor, 34
Strelow, Liselotte, 11n

Talma, Francois-Joseph, 12
Taylor, J., 68
Tinbergen, N., 40n
Toepffer, Rodolphe, 24, 31, 90
Tolman, E. C., 63
Tolnay, Charles de, 2n
Toulouse-Lautrec, Henri de, 12

Valloton, Felix, 22, 23 (fig. 19)
Velasquez, Diego, 27 (figs. 24, 25), 28, 42, 45n, 46 (fig. 37)
Vincent, Clare, 2n

Waetzoldt, Wilhelm, 1n
Weaver, Warren, 105n
Wengraf, Paul, 2n
Wheeler, Monroe, 2n
Wiese, E., 24n
Wimsatt, W. K., Jr., 127n
Wittgenstein, Ludwig, 98, 119n
Wolfflin, Heinrich, 35
Wollheim, Richard, 115n, 129n
Worringer, Wilhelm, 35